THE WISDOM OF OUR HANDS

Crafting, a Life

Doug Stowe

LINDEN PUBLISHING

Fresno, California

All photographs and images provided by the author
unless otherwise noted.
Front cover image courtesy Arshia Khan.

Published by Linden Publishing®
2006 South Mary Street, Fresno, California 93721
(559) 233-6633 / (800) 345-4447
www.lindenpub.com

Linden Publishing and colophon are trademarks of
Linden Publishing, Inc.

ISBN 978-1-61035-501-8

135798642

Printed in the United States of America
on acid-free paper.

Library of Congress Cataloging-in-Publication Data

Names: Stowe, Doug, author.
Title: The wisdom of our hands : crafting, a life / Doug Stowe.
Description: Fresno, California : Linden Publishing, [2022] | Includes
 bibliographical references and index.
Identifiers: LCCN 2021060795 | ISBN 9781610355018 (paperback ;
acid-free
 paper)
Subjects: LCSH: Sloyd. | Woodwork--Vocational guidance. | Woodwork
(Manual
 training)--Psychological aspects. | Quality of work life. | Stowe,
 Doug--Philosophy. | Industrial arts--Study and teaching--United
States.
Classification: LCC TT187 .S75 2022 | DDC 684/.08023--dc23/
eng/20220201
LC record available at https://lccn.loc.gov/2021060795

CONTENTS

DEDICATION

To my wife, Jean, and daughter, Lucy.
The support of family is essential to the artisan's work.

ACKNOWLEDGMENTS

As I began work on this book, I found that I was not alone in my thinking about the wisdom of the hands. There are present and past educational theorists aplenty who share my perspective regarding the importance of hands-on learning. I found encouragement from getting to know a number of interesting folks and being recognized by them for the ideas I shared through my magazine articles and through my blog, *Wisdom of the Hands*. While writing and corresponding have helped me develop my ideas, my woodshop is where I've been able to explore these ideas with my hands, my tools, and what I've found myself able to do with them.

I have a few folks to thank. My sixth-grade teacher, Mrs. Mummert, recognized that I had some ability to write. That proved true much later in life as I wrote fourteen woodworking books, more than a hundred how-to articles in woodworking magazines, and additional articles in educational journals.

In 2000 I began writing articles for *Woodwork* magazine, and I owe sincere thanks to its managing editor, John Lavine. He gave me the chance to write about projects in my own shop and then about Educational Sloyd, the handcraft-based education system. My articles in *Woodwork* were the first time most American woodworkers had ever read of Sloyd, even though it had played an important role in the rise of shop classes in American schools and was still a part of compulsory education in Scandinavian countries. I am particularly indebted to a friend and mentor in Sweden, Hans Thorbjörnson, who was my guide

on a visit to the home of Sloyd and served as my ready reference for a period of years as I learned about the system.

My articles about Educational Sloyd brought me friendships with Frank R. Wilson, who wrote the important book *The Hand: How Its Use Shapes the Brain, Language, and Human Culture*, and Elliot Washor, cofounder of the Met School (an innovative high school in Providence, Rhode Island) and Big Picture Learning (which presents a new model for high schools throughout the world). Both of these men helped me to feel secure in my ideas and helped me to find greater confidence in sharing them with you, as they are not mine alone.

Thanks to philosopher Matthew B. Crawford, who quoted a passage from my blog in two of his books, *Shop Class as Soulcraft* and *The World Beyond Your Head*.

I want to acknowledge, among many correspondents, David Henry Feldman and Jerome S. Bruner, both well-known authors in the field of education. They have not only helped me to feel more confident in my studies and more confident in my voice but also contributed their ideas to me.

I offer special thanks to Richard Sorsky at Linden Publishing for seeing the need for this book, and to my editors, Clare Jacobson and Kent Sorsky, for bringing it to a more coherent form.

At this point I've had twenty great years teaching at the Clear Spring School, and I owe a debt of gratitude to the parents, board, administration, and staff for providing an environment where my philosophy of hands-on learning could be practiced and mature. Throughout these years my program has received the support of the Windgate Foundation. I will be forever in its debt.

Then there are hundreds of people who have advanced my work by buying it or reading about it, or by joining me in class. My students include children from preschool through high school and adults of all ages. To each and to all, I express my thanks.

FOREWORD

In my book *Shop Class as Soulcraft*, I made reference to woodworking as being a hippie craft, one that did not capture my attention in the ways I was captured by the mechanics of motorsports. I did, however, choose a quote from woodworker and teacher Doug Stowe as the epigraph for chapter 1 of the book. I used it because it is a perfect description of the failings of an American education in which shop classes have been left behind. I used that same quote as the basis for further discussion in the closing chapter of a subsequent book, *The World Beyond Your Head: On Becoming an Individual in an Age of Distraction*.

Here is Stowe's quote: "In schools, we create artificial learning environments for our children that they know to be contrived and undeserving of their full attention and engagement. Without the opportunity to learn through the hands, the world remains abstract, and distant, and the passions for learning will not be engaged."

I don't think this is true of every student, but it is true for enough students that we ought to worry about it. A due regard for the diversity of human excellence would include a due deference to the diversity of learning styles. But let us go further: to encounter things directly is more fundamental than doing so through representations, so maybe we needn't regard hands-on education as second-class, and those who require it to flourish as second-rate. Very few of us are scholars by nature, and it seems strange that sitting at desks and looking at books would become the norm of universal education.

Stowe puts his finger on the problem when he suggests that many students are sitting there in class with the silent conviction that what is on offer is "undeserving of their full attention and engagement." This problem is surely exacerbated by the availability of hyperpalatable mental stimuli. But I believe the more basic issue is the disembodied nature of the curriculum, which divorces the articulate content of knowledge from the pragmatic setting in which its value becomes apparent. By contrast, suppose a student is building a tube frame chassis for a race car. Suddenly trigonometry is very interesting indeed. To reclaim the real in education would be to understand that one is educating a person who is situated in the world and orients to it through a set of human concerns. This is more effective than addressing oneself to a genetic "rational being" and expecting him or her to get excited. Our current regime of education has been flattened in this way.

As Stowe's use of the word "undeserving" suggests, at the heart of education is the fact that we are evaluative beings. Our rational capacities are intimately tied into our emotional equipment of admiration and contempt, those evaluative responses that are inadmissible under the flattening. A young boy, let us say, admires the skill and courage of race car drivers. This kind of human greatness may not be available to him realistically, but it is perfectly intelligible to him. If he learns trigonometry, he can put himself in the service of it by, for example, becoming a fabricator in the world of motorsports. He can at least imagine such a future for himself, and this is what keeps him going to school. At some point, the pleasures of pure mathematics may begin to make themselves felt and give his life a different shape. Or not. He may instead become enthralled with the beauty of a well-laid weld bead on a perfectly coped tubing joint—like a stack of shiny dimes that has fallen over and draped itself around a curve—and devote himself to this art. There are websites for "weld porn," and the mere fact that this is so should be of urgent interest to educators. Education requires a certain capacity for asceticism, but more fundamentally it is erotic. Only beautiful things lead us out to join the world beyond our heads.

Stowe's book, however, is not purely about our current educational model. Using woodworking as a basis for discussion, he investigates the ways learning hands-on with real tools and real materials, using techniques we've learned either for ourselves on our own or from others, offers a means for personal, cultural, and economic transformation, for both children and adults of all ages, and applies even to the art of motorcycle maintenance and repair.

—Matthew B. Crawford, author of *Shop Class as Soulcraft*

INTRODUCTION

You may be one who need read no further in this book than its title. The title alone may suffice. You may be one who has lived your life just as I have mine, knowing that your brains are in your hands. For me, with this knowledge, I set about making a life for my hands and for the rest of myself at the same time.

In the early winter of 1969–70, I went home from college with the idea of telling my parents I was dropping out. There I had a talk with my friend Jorgy, who had helped me to restore a 1930 Ford Model A Tudor Sedan. Jorgy asked me why I was studying to become a lawyer when my "brains were so obviously in my hands." That simple question led to my changing course. I went back to school and adjusted my focus from sociology and political science. I managed to make that senior year tolerable and more interesting by taking classes in creative writing and ceramics. Through the good graces of a compassionate faculty, I was able to graduate and move on. I ended up putting my life on a healthier course.

I've since learned that this kind of story is common. My own story reflects the experiences others have shared with me. At some point, early or late in their lives, many others have decided to move from the world of the abstract into the real world. As a woodworker and teacher I've met so many others of my kind. Lawyers, doctors, engineers, and businesspeople of all sorts have found their way into my classes, driven by a need for creative expression and tangible effect, a need made known to them by the sense that their lives had become overly abstract.

That the brain and hands are intricately intertwined should not be a surprise to any of us. The fifth century BCE Greek philosopher

Anaxagoras said that man is the wisest of all animals because he has hands. Scottish physiologist Charles Bell wrote in 1833, "The hand is the instrument for perfecting the other senses and developing the endowments of the mind itself."[1]

There's a deep meaning to the word "hands," as they are symbolic of the whole person. When the first mate calls for "all hands on deck," they've made the assumption that with the hands come minds and spirits engaged in absolute readiness to save the ship. The hands are also symbolic of our learning. When we say that we learned "hands-on," we're referring to not just our hands being present for the exercise, but our full presence—body, mind, and spirit as well as hands. I'll attempt to explain how being present is the actual embodiment of craftsmanship, and that in our attempts to craft useful beauty, what we are also crafting is ourselves.

As I began to awaken to the transformative powers of my own hands and brain working in partnership, I realized that the brain is much more potent a creative force when the hands are involved in the brain's deliberations. I became a potter and then a woodworker in Eureka Springs, Arkansas, a small town dedicated largely to the arts. There are significant lessons from this experience that I'll share, with the hope you will find them transformative not only for your own life but also for our culture at large. Similar transformations have played out in the lives of artists and craftspeople of all kinds. Attention to the ways these transformations are shaped can allow you to become better at what you strive to do and make your life more meaningful to yourself and to all.

I began working on this book around 2001, concurrently with my decision to teach woodworking at the Clear Spring School in Eureka Springs after twenty-five years as a self-employed craftsman. Observing my own learning in my own shop and witnessing the broad array of interconnected disciplines related to woodworking (marketing, math, physics, literature, psychology, design, and more) had given me the impression that I knew a few things about how learning worked. That led me to what seemed a preposterous notion, that we might

revise American education to make better use of our hands. I realized, however, that without my actually becoming involved in American education, my own voice would be hollow. In order to present a new model, I would need to flesh out that model through actually teaching kids. My idea was simple: the use of the hands is essential to learning, and parents, teachers, and schools that choose to ignore that put severe limits on their effectiveness and their children's futures.

I've been informed by my publisher that I've tackled an overly ambitious book, trying to accomplish two books in one, both of which need to be written. One is an attempt to describe artisans' personal growth as makers of beautiful and useful things. The other involves transforming human culture and economy by taking the hands into greater consideration. I propose that both of these books are the same book, and that teaching and craftsmanship are a singular journey along a shared path, a thing that I hope you'll discover as you read along. I suspect that many of you who are artisans or aspire to become artisans have already become aware of the shortcomings of modern schooling but may not have yet arrived at an understanding that its inadequacies can be fixed or that you might be the person to fix it.

There's a terrible, disparaging thing that some say about teachers: "Those who can, do; those who can't, teach." As one who comes from a line of teachers, I hope to speak in their defense and point out a few things that people learn from teaching (and writing) that serve the craftsperson's growth. So, watch for this in the book.

My own journey from craftsman to teacher is one that other craftspeople may find familiar. When we've crafted something, we feel an immediate urge to share what we've made with others. This may be simply to gauge their response in hopes of admiration. Often when I make a box of a new design, I'll set it on the kitchen counter, expecting compliments or at least useful criticism of my work. Beyond this small inclination, we each hope to shape the world beyond the object we've so carefully made. We want the world to reflect the feelings we have about it. Where we've found beauty, there we also want others to find beauty. Where we've attempted to make the lives of others better or

easier by crafting some useful thing, we want that object to be useful and actually deliver upon our intent. And the need or urge to do these things, leaving our own marks upon the world, grows more intense as our days begin to number but also as our own strengths become apparent to us.

I call upon woodworkers and other craftspeople, those who feel the same longing that the world be made whole, to consider that the urge to share your work and what you've accomplished makes you a teacher whether you are working alone in your own shop or taking a more overt approach.

Beyond that, and of course first, no artisan is an island unto themself. As I work to describe a philosophy of work and workmanship, I'll note that no good philosopher worth their salt will wander far from reality that can be observed and measured as actual experience. A favorite story concerns three philosophers who, walking on a starry night and sharing their sense of wonder at it all, fell into a drainage ditch. And so, philosophy at its best is derived from experiences like those we may find in our studios and workshops, close to the reality of tools, materials, and the desire to create. As Jean-Jacques Rousseau said, "Put a young man in a woodshop, his hands will work to the benefit of his brain and he'll become a philosopher while thinking himself only a craftsman."[2]

In that word "only," Rousseau introduced the importance of humility, one of the essential ingredients for growth. There is a really fine and vastly important thing that happens in craftwork. We make mistakes—we are human, after all—and those mistakes (if we do not fall into the demobilizing trap of self-recrimination) can keep our own humility intact and our humanity in sight. There is no more important attribute through which to engage others or to engage life. Humility is like the glass half full waiting to be topped off by fresh learning and new relationships with an ever-expanding sense of the wholeness of life.

A good friend of mine once said that every act of creation is a narrative endeavor in which we hope to tell our own story. You'll find

the word "narrative" to be an important concern in several places in this book, for finding ways to tell our own unique stories is a large part of why we make. And just as a novelist would, a craftsperson attempts to build a story powerful enough that it resonates with its audience.

I want to tell a bit about how this book is laid out. We are all shaped as artisans by the materials of our choice, the tools we have available to us, and the techniques we've been allowed the opportunity to learn, including those we've been taught and those we've taken upon ourselves to learn on our own. In addition, developing a design sense and the ability to express ourselves though the materials, tools, and techniques is of vast importance. So, chapters on materials, tools, techniques, and design and what we can learn (and our hands can teach us) from each come first.

Those four chapters are followed by a few more attempting to reach further into the heart of the matter. How do you grow your skills as a craftsperson to make the world a better place? For surely as you grow in your work the world does become better. It becomes better still when you share with others what you've learned and who you've become. As you grow in skill and understanding and the world does the same thing, it becomes more receptive and supportive of your work. So, what if you are not a craftsperson or artisan and have no interest in moving your life in that direction? There are still things you can do to help recraft our economy and culture in a more handsome and meaningful direction. Assist others in learning to craft, and infuse your own life with the things they've made.

Now, before we begin, I want to briefly address the matter of late blooming. Learning hand skills, like learning a foreign language, has particular blessings of ease among the young. Just as a pianist who starts training at a young age has the upper hand, those who begin crafts and the development of hand and mind associated with them at an early age have a distinct advantage over those who start later. But whether you begin crafting early or late, you will find joys that come with learning. And when you can tell someone that you learned hands-on, they will know that you learned something at great depth.

For some readers, I will be reminding you of a few things you already know. Some will say that I'm preaching to the choir. Let's think of this book and the story I tell as choir practice, in the hopes that we all become better spokespeople for our hands, sharing how we learn best, and that we learn to be our best in the process.

CHAPTER 1

MATERIALS

"The smell of resin and fresh wood, the sight of the smooth, clean cut made by a newly sharpened axe blade—such things can fill a man with a wordless joy and put him in touch with the essential joy of all physical labor: In his own hands he weighs the feel of life itself."

—HANS BØRLI

E arth, wood, stone, clay, iron, fibers, paper, and glass—these are the foundational materials for crafting civilization. Without earth, there's no agriculture to feed craftsmanship. Without wood, our ability to build other things is impaired. And stone? Without miles of stone walls to shore up hillsides and paths and buildings, towns like my own would not exist. If we had no steel or iron, we would not have the tools necessary to shape any of the other materials.

Perhaps fibers, paper, and glass may have come late to the list of materials essential to civilization, but they are no less important to it. The Sumerians kept their records on clay tablets, Incans saved theirs on knotted string, and the Vikings chiseled their poetry in runes on stone, so without paper, record keepers might get by, for a time at least—and poets might get along with wine alone. The poet James Richardson suggests that wine should be added to the list of

foundational materials. Perhaps so. Let's adopt wine as a stand-in for the human spirit.

The wide range of available materials makes it hard for a potential artisan to choose. Each material has the potential of linking you to the broad expanse of human culture. But rather than be a jack of all materials and master of none, you would do better to choose one that has the strongest personal appeal as a primary focus. (Joni Mitchell wrote in a pop song about the contrast between "the thumb and the satchel or the rented Rolls-Royce," the consequent "crazy you get from too much choice.") Let that material shape you as your soul demands. Each material has its own constraints as to how you can use it successfully, and each has its own traditions for working around those constraints. Each is poised on a threshold of fresh understanding.

Throughout much of human history, we have attempted to shape the materials found in our natural environment into new, more useful forms. The materials have given us shape as well. I'm reminded of Ted Reser, an elderly blacksmith in the town of of Valley, Nebraska, where I worked in my dad's hardware store. Ted would come into the store bearing the blended scents of coal burned in the forge and sweat. He was proud of his bulging, well-developed chest and arms and was deaf enough from the ring of the anvil that he thought everything a woman might say in the tavern next door was directed in admiration toward his powerful physique. That may or may not have been the case.

While Ted may be an extreme demonstration of the marks of one's chosen materials, materials can offer more subtle and more meaningful changes as well. By making a choice and holding to it, you give definition and clarity to your work, and to your life as well. A material can lend itself to deeper investigations of life itself and can affect what you are able and compelled to share with family, community, and friends. We each bear the markings of our chosen lives. In my own case, I've proudly worn the stamps of my woodworking as calloused hands, a trail of sawdust on my shirtsleeves and pant legs, and the blended aromas of wood dust and sweat.

Each material has its own constraints that affect what artisans can and can't do with it. Each requires that you develop a sensitivity to its working qualities. For example, clay must be mixed with water to the right consistency. If too much water is added as you throw a pot on the wheel, the pot will slump and fail. If the clay is too dry, you'll not get it to center easily on the wheel. If it's not been wedged properly, a thing many choose to do by hand, it can have air bubbles in it or inconsistent moisture content, again causing problems as you attempt to raise it on the wheel into a uniformly thin, balanced, and shapely form. If you let a pot dry too long, it will be impossible to trim as nicely as you would have done while it was leather hard. If clay is too thick and not well enough dried in advance of firing, pots can blow up. These are things that you learn from experience, but also that you must watch carefully throughout the process.

I could have loved a long life as a potter, crafting functional things from clay. I think back to my potting days, fondly remembering reaching my arm beyond elbow deep into a pot as I turned it, an exercise that required me to stand at the wheel. If I'd potted longer, I might have gotten good enough to throw porcelain on the wheel, which takes additional sensitivity and practice. More recent experience in a blacksmithing class taught in the blacksmithing shop at the Eureka Springs School of the Arts tells me I would have thoroughly enjoyed life as a blacksmith. When guests come to our home and are offered a beer, I swell with pride when they use the beer opener I forged from red-hot steel on the anvil with a hammer wielded by my own hands.

I made a choice, dictated by circumstances, to pursue a career as a woodworker. My choice of working material does not suggest my judgment of other crafts, as I think you should choose for yourself and choose well. And that choice should fit your own temperament and inclinations within the constraints that the material offers.

Among materials used for artistic expression, wood has unique limitations. If you cut a piece of steel too short, you can heat it in a forge and hammer it on an anvil, thinning it and extending its length. Lacking a forge, you can widen your weld, simply filling it in with hot

steel, and then grind the unsightly gap. If clay is too long or too short, you can squish or stretch it to fit (provided it is still wet and therefore plastic enough to do this). If your pot fails completely, you can wet and wedge its clay again, gaining endless opportunities to get at least one pot right. Wood often requires precision, particularly when what you make is assembled from a variety of parts. Woodworkers joke about needing a board stretcher. No such invention has been made, nor can it be. And there's another joke: "I cut this board twice, and it's still too short." Cut it once; it can't be uncut. Cut it once and there's no going back. On the other hand, due to the natural expansion and contraction of solid wood, building too tight and not allowing wood to move a bit can cause a finished piece to push apart at the joints.

Certain inherent characteristics in wood make it challenging. They also make it lovely. What more need I say? The Austrian artist Friedensreich Hundertwasser said, "Among trees you are at home." That is the feeling I have about wood. And your feelings about the material you choose to work in should instruct your path.

Most of the materials used in crafts can be found in nature, and craftspeople can choose how deeply to go into procuring materials for making art. For example, Eureka Springs High School art teachers have taken their students to a local cave to dig clay for making pots. There's a good reason to go deep into materials—to gain the best understanding of a craft. Another example: members of the Blacksmith Organization of Arkansas gathered to build a clay bloomery in which they could smelt raw iron from ore. They consumed gallons of beer, forged friendships, and acquired a deeper understanding of the material process, but they created only a little iron. Measured in iron the event was a failure; measured in other things, a resounding success.

Memorable stories and connections can be found in going deep, harvesting materials yourself while also harvesting, in narrative form, your own life. By doing so, you can lay claim to more of the creative process. The greater your understanding of your materials, the more clearly you can see your own creative options. This doesn't mean that the clay from the cave would offer many advantages over store-bought

clay that's been carefully formulated and mixed to the demands of a studio potter.

Then again, choosing irregular materials can benefit production. Manufactured woods like plywood and medium-density fiberboard (MDF) come from an industrial approach, in which whole forests are turned into commodities for international trade. These woods come in standard-size sheets, making it easy to plan projects with them. This is not the case with solid woods. Hardwoods, for example, are sold in random widths and lengths, making it more of a challenge to deliver a standardized project with them. That challenge opens the door wide to the woodworker's individual judgment and development of a personal design sense.

Early in my career I considered making furniture for sale through galleries or catalogs, but I found that standardizing my production would not allow me to be very selective in the placement and orientation of wood grain or to use the variations of colors and features in the wood to their best advantage. That realization led me very firmly in the direction of making unique one-of-a-kind pieces and never exactly repeating what I've already made. By not standardizing the products I've made, I've also avoided, to a degree, the standardization of myself.

Working with solid woods invites us to use the woods that grow around us. It invites us to appreciate our trees and forests at a deeper level. With reverence for the material, we humans may admit to ourselves as true what we are beginning to learn about trees and forests. Peter Wohlleben—German forester, scientist, and author of *The Hidden Life of Trees*—and other scientists, including Suzanne Simard at the University of British Columbia, suggest that trees have the means to communicate with each other and protect each other from threat. Trees are sophisticated organisms that live in communities, support their sick neighbors, and have the capacity to make decisions and fight off predators. Wohlleben and Simard have been criticized for anthropomorphizing trees, but they maintain that to succeed in preserving our forests in a rapidly warming world, we must start to look at trees in

an entirely new light. Woodworkers can play a role in promoting this understanding of trees. By better understanding how our materials are sourced we can help to weave a sense of the interconnectedness of all life. By doing so, we can find greater meaning and purpose in our work and greater respect from others as we do it.

There are clearly wonderful things about wood. Trees grow from the earth. They pull minerals and water from the earth, process carbon dioxide from the air to provide oxygen, and then grow large and strong in their relationship to gravity and light. Of course you know all that, and there are few living things that have engaged humans' imagination more than our trees. We write poems about them. Civilizations have risen and then fallen in direct response to how people have managed or failed to manage their use of forests.[3]

Where there's a knot in wood, there once was a branch. Trees and the wood that comes from them are very much like human beings in that they tell their stories and we tell ours. One difference between trees and humans is that trees don't jabber. They are far more truthful and authentic than we are. There was a murder case in Arkansas that was solved by a dendrochronologist who analyzed a piece of firewood that tied the murderer to the particular piece of land where the crime took place. And so, while people make stuff up, wood is truthful in telling its experiences and processes of growth, even long after it is cut.

Woodworkers may choose to allow the wood to tell its story or use it to tell their own. Or they can attempt to achieve a balanced approach, telling their own story while also giving voice to the trees and the forests from which the wood came. Woodworkers may choose to display incredible skill in manipulating wood, or they can allow the wood to have more of its own voice in the creative process. Or they can clearly express the story of the forest and still take the opportunity to show off a thing or two. That has generally been my approach to woodworking.

Artisans working with epoxy or bronze, or steel or stone or glass or clay, will proclaim the wonders of the materials with which they create. If I were them, I would do the same. There are indeed wonders to

each. But wood connects you directly to the natural world. It emerges abundantly on the surface of the earth, nearly as a gift. You can walk into the forest with an axe or a knife, find a deadfall branch, and begin making art. In my humble opinion, no other material lends itself so directly to humans' creative genius. You can go directly from what you've observed growing in the forests surrounding you to producing your own creations, offering beauty and utility that lasts far beyond the short term of your own life.

In New York City's The Cloisters museum, there are nine-hundred-year-old wooden things: chests that have held their form even though crafted with only the simple tools of the time, religious triptychs that open to scenes of holy significance, carvings of famous historic religious figures, and much more. Compare these with the desk we bought my daughter from IKEA. It made it through one move, but no more. In another favorite museum of mine, the Nelson-Atkins Museum of Art in Kansas City, there is a wooden statue of Guanyin over a thousand years old. In a secret compartment, curators found a scroll containing the names and signatures of the artisans who carved it. And so, to realize that something you make can outlive you—for generations or even centuries if crafted with enough integrity that others love it enough to keep it and care for it—allows you to think lovingly about your own work and give it your best shot.

Is longevity enough? The feel of the material is also something to consider. While things made of clay last nearly an eternity, clay as it is worked may be wet and cold and may leave your hands feeling dry and cracked. Metal may be cold enough to sting or hot enough to burn. But the working temperature of wood is just right. What about splinters, you ask? Well, there is a distinct sense of pleasure as the work proceeds, sanding or planing or scraping wood from rough to smooth. The splinters on rough wood demand careful, even reverent, handling, but the shavings from rough metal are worse. Wood, when it's sanded or scraped or just worn from daily use, is a joy to touch.

You can take a variety of approaches to wood, depending on your

own temperament and situation. A professional woodworker with a deadline and a tight budget might necessarily rely on power tools. An amateur woodworker who can take their own sweet time might alternatively use hand tools, which allow many slow, contemplative moments to be savored and recorded in making a piece that lasts generations. Even professional woodworkers will resort to hand tools on occasion to gain a greater sense of and sensitivity to the wood, and they will cherish the joy to be found in that.

There are people whose need for contact and connection with the world may extend no farther than the keyboard or touch screen of their device. Most of us, however, feel the necessity of getting our hands on something concrete, deeper, and more lasting. Working with wood and, of course, the other materials for crafting civilization can offer the same level of distraction and compulsive depth of engagement that a device can, but with some distinct differences.

When you make something from wood, stone, steel, clay, or glass, there's the chance of it being tangibly useful to others. Things made of these materials have depth and texture and weight. They are of this world and strongly fixed in human consciousness and heritage. They invite ceremony and reverence.

What you make stands as evidence of learning, of growth, of caring, and, in essence, of who you are. Each craft has its own material qualities, origins, traditions, specialized tools, and work methods to be learned. Allowing the material to directly shape your life and enrich and enliven the contributions you make to others is inevitably a personal story, but one that factors in the situation in which you live and work.

As I was beginning my woodworking career, I went to Nations Hardwood Company, a place known for its wide variety of Arkansas hardwoods. There are two broad categories of wood: hardwoods and softwoods. Softwoods are commonly used in the building trades. You can usually pound a nail through a softwood board, while this will be more difficult with most hardwoods, which require assembly methods of their own. Hardwoods, a few of which are softer than many

softwoods, are generally slower growing and have broad leaves that are often lost in the fall. But this is not true in all cases, as some tropical hardwoods do not shed their leaves by season.

From Nations I carried home cherry, honey locust, persimmon, hickory, sycamore, ash, chinkapin, and maple, in addition to the better-known oak and walnut. Nations introduced me to many woods I'd never heard of, even though they were growing all around me. And yet, when I first moved to Eureka Springs, many hardwood trees were being cleared indiscriminately to create pastures, to build motels and gas stations, or to grow short-term-profitable pine trees in their place. After buying lumber at Nations, I knew what Arkansans were losing as our hardwood forests were purposely killed.

Arriving home from my first visit to Nations, I went to sleep that night thinking about the beautiful varieties of wood I'd secured and wondering what I could make from them. My dad, who had recently died, had given me two dozen cast-bronze combination-lock post office doors. I woke up in the middle of the night with a thought about making post office door banks with multicolored inlays of the beautiful woods. By morning I knew how to make the inlay as lovely as my father's memory deserved, and by noon that day, my first inlay material was ready to use. It was simple and would grow more complex in time. Is that not the simple way of things? We start with a relatively simple idea and then, by our working with it over a period of time, it works into something of value to us.

The banks sold quickly, and the inlay technique became useful to me as I began to develop my work. Over the years since, I've sold thousands of inlaid boxes through galleries throughout the United States. Some were carried as gifts of state by Arkansas governor Bill Clinton to Asian countries. And these small pieces became essential to my survival as a craftsman, allowing me to have work to do between furniture commissions. They helped me to build a clientele for larger work and later attracted a publisher to ask me to write my first book.

The simple inlay technique that I discovered for myself in nightly

imagination was interesting enough that folks wondered how I might do such things. They asked, "How do you cut such tiny pieces, and how do you put them together like that?" I would carefully explain my technique to all who showed an interest, but even knowing how easily it was done did not erase the association that folks placed on it as being quality work.

Again, what's so special about wood? In my case, it was something that dreams were made of. There are enough things to learn from woodworking to keep a person learning for a lifetime. There are several joinery techniques that a successful woodworker must learn. And then there are the decorative techniques you can add for good measure. Or you can spend a whole lifetime, as many woodworkers have done, on woodcarving alone.

There are many aspects to wood that most woodworkers learn over the course of time. One important feature of wood is that it has grain. The grain in different species is not the same. In some, like elm, it is tightly interlocked, which prevents splitting. My first experience with elm came when a tree had to be cut down at my sister's house. Thinking I could play lumberjack with an axe and provide my sister with some fireplace logs, and not knowing about the grain in elm, I bought an axe and went to work. I quickly learned that operating an axe and getting it to strike where you want requires practice that I'd not had. Compound that with the interlocking grain, and it did not take long for me to begin worrying that I might become a danger to myself. Fortunately, I became exhausted before any damage to myself or my sister's property took place. But those logs and branches would not split. So, you might guess that elm would be good for something other than firewood. It is. There are many worthwhile things you can make with elm. In fact, that interlocking grain makes elm a perfect wood for steam bending, among many other things.

Wood grain makes a difference. Some woods have distinct visual characteristics, so you learn in time to recognize their differences on sight. But all woods have a thing in common. When you are using a tool, going with the grain or against it can make a difference. It's

like petting a cat. If you pet it the wrong way, the cat will likely let you know, even if your own senses do not. If you plane wood the wrong way, it too will let you know by offering greater resistance and greater likelihood of tear-out (tiny removed chunks or raised slivers that interfere with the visible and tactile smoothness).

Wood, we learn—either from a teacher or from the wood itself—is never a dead thing. It constantly expands and contracts across its width and thickness in direct response to changes in relative humidity while remaining stable in length. Unless kept in a perfect climate-controlled environment, it is always swelling or shrinking. If woodworkers think they can get away with just cutting parts and slapping them together with glue, they'll be disappointed when their work pops apart.

If you look at wood at the microscopic level, you learn that it is composed of long tube-like cells. When wood is freshly cut from the forest, its cells are swollen with moisture. As wood dries, the cells lose their water and the cell walls collapse inward, causing the wood to shrink and sometimes split or warp. Wood is responsive enough to this phenomenon that you can watch it happen within hours. For example, you can lay a perfectly flat board out in the sun and see what happens. The underside, exposed to the damp ground, will expand, while the top side, heated by the sun, will dry, and the tension between the two will cause the board to curl upward on its edges.

The power inherent in wood as it goes through its process of expansion or contraction is enormous. In one of my early furniture commissions, I was asked to build a table from solid oak. The customer, being as ignorant as I was at the time, asked that I build it from kiln-dried wood, as he had heard that kiln-dried wood was "stabilized" and immune to expansion and contraction. So, I glued up the tabletop and firmly attached it to a trestle-style structure I'd built to support it. Setting it outside my shop on the day it was to be delivered, I watched as the humidity did its work, forcing the wood to expand against the restraint of the screws in the structure underneath. The top curled, leaving the table unusable until I took the screws out and arranged for the top to expand and contract independently of its base. That was the

kind of Woodworking 101 lesson that beginning woodworkers often face. On another occasion, I glued up solid wood sides for a display cabinet. After a thunderstorm, the width of the sides became ¼ inch wider than they were the day before, while their length remained the same. It told me once again that a woodworker using solid woods must allow for the inevitable. And of course, each material an artisan might choose to express their own aspirations carries similar lessons that are best learned by experimentation and failure.

Understanding the history of a material is essential to success in working with it. As a young potter, I'd been drawn to the simple tea bowls of Shōji Hamada. How could something that simple be so lovely? There are very clear reasons for modern craftspeople to take a more traditional approach to their chosen material.

I began learning traditional woodworking joinery techniques and incorporating them into my work. A customer in Arkansas commissioned a chest of drawers from me and another one from a competing woodworker in town, and moved both pieces to Colorado. A couple months later he called me to tell me that he'd been awakened in the night by what had sounded like two gunshots. The loud sounds were made by wood, having shrunk and split apart in the dry mountain air. Each cabinet side had popped, leaving a ¼-inch gap. To my relief, the midnight explosions were in the furniture made by the other craftsperson, not in the piece I'd made with floating panels, mortise and tenon joints, and hand-cut dovetails. The chest I made was a testament to the traditional joinery techniques used in making it.

Unlike unforgiving solid woods (which I have a tendency to call "real woods"), manufactured woods like particleboard, plywood, and MDF avoid expansion and contraction from seasonal change. I've used those products when required by certain projects, but I am drawn primarily to traditional techniques that are required by working with solid woods. Working with "real wood," you have the opportunity to use materials that grow in your own community, whereas manufactured woods have adverse effects on the worldwide environment. In a strange irony, walnut logs are harvested here in Arkansas, loaded into

trucks, then railroad cars, then barges on the Arkansas River, then taken aboard ships to *where?* Then they're milled and dried in sheets that are used as face veneers on plywood panels (the cores of which come from places like Borneo, where forests are being destroyed), and then the end product is sold back in the United States. The choice may appear stark: learn the joinery techniques associated with traditional wood or use manufactured wood products, for which the environmental costs may be enormous.

The aesthetic experiences associated with working with solid woods are more good reason to use them. When I examined my first load of Arkansas hardwoods from Nations, I learned things about each species of wood. For instance, there's nothing smoother to the touch than persimmon when it's been planed or sanded. It's a heavy wood and the only North American member of the ebony family. It was traditionally used for making shuttles for weaving and for the heads of the golf clubs called "woods." A fruitwood, persimmon has a pleasant smell, much like the fruit it bears in the fall in the Ozark Mountains.

If you love pancakes with maple syrup, run a piece of sugar maple through the table saw. The smell of the wood will not disappoint. Some cherry I've sawn smelled like cherry cough drops. If you love root beer, cut sassafras. The roots gathered from that species were the first American export. The colonists at Jamestown attributed their survival from starvation to having been introduced by Native Americans to sassafras tea. It is said that when the Pilgrim colonists arrived at Plymouth on the *Mayflower*, the ship's hold had been made sweet by the strong smell of cargos of sassafras root. When I made inlay from these woods, the saw blade passed from one species to another, and the distinct scent of each arose in turn.

In addition to its unique fragrance, each species has its own appearance. Some have distinct grain. Some present a more subtle look; some are recognizable by their color. Each will age, often changing color over the course of time. One customer loved the color of freshly cut cherrywood, but I warned her, "It won't stay this color." Cherry, as it's exposed to sunlight, turns darker. "Can't you keep it

light like this?" she asked. "No, but you will love it," I assured her. And thankfully she did. When you know what woods will do in time, watching them age into your own life and in your own home is like growing older with friends.

I've been making inlay from Arkansas hardwoods for about forty-five years now. While my inlays are not sophisticated craftsmanship, they allow me to highlight the importance of forest diversity and to introduce lesser-known woods to those who know little about our forests or the beauty within them. My hope is that, as folks become more aware of the beauty of our American hardwoods, greater efforts will be made to keep our natural forests safe. I reiterate, working with solid woods has the potential of connecting us to the natural world that exists right outside our front doors.

There are many things you need to know about working with solid woods. One is to be patient and plan ahead. Hardwoods, if properly stored, air-dry enough for typical work at a rate of one year per inch of thickness. So, a one-inch-thick piece of wood must be stored in the dry for a full year before it'll be ready for use. It took many years of woodworking before I had the resources to build a barn to dry and store wood. Having the capacity to store, dry, and wait for readiness allows you the luxury of buying wood directly from a sawmill and drying it yourself. If your time is worth money, you may find no savings in that, as you'll end up stacking and restacking and moving the wood a few times before you are ready to use it. But drying wood yourself allows you to develop a solid relationship with your work.

The alternatives are to work with green lumber (wood freshly cut) or to buy wood that's been kiln-dried. The advantage of working with green lumber is that it's cheap and, because its cells are fat with water like ripe tomatoes, it's easier to cut or plane. The disadvantage is that when you're finished with a piece of furniture, nature is not. Parts will shrink. In most cases, a lot.

Kiln-dried wood offers the advantage of being ready to work, but because of the drying process used, many traditional woodworkers feel that it doesn't "work" as well as air-dried woods. Also, it still expands

and contracts just as air-dried wood does, so you still need to use the same joinery techniques on it.

Our efforts are constrained by the willingness of wood. It will do only certain things and in certain ways. It will bend without breaking only under controlled heat and stress. It has grain that determines how individual species and individual pieces can be best used. Each species has its own qualities, so getting to know wood, species by species, is a wonderful venture, and you will learn things.

"Quarter sawed" or "rift sawed" lumber is lumber sawed so that the face of the boards is parallel to the medullary rays, or nearly so (Fig. 28).

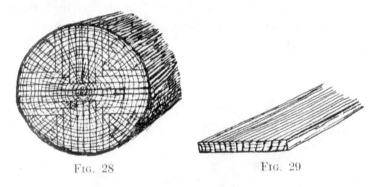

Fig. 28 Fig. 29

Boards sawed in this way do not warp or twist much, as the yearly rings are on edge, through the board (Fig. 29).

From *High School Manual Training Course in Woodwork*,
by Samuel E. Ritchey (New York: American Book Company, 1905).

For instance, when I first worked with sycamore, as I passed the wood on one side across the jointer, it warped instead of getting straight. I learned from experience, confirmed by research, that sycamore is notorious for going wayward unless you use quartersawn wood, meaning it's been cut with the boards in line from the center to

the outside of the tree. (The drawing above shows the sawyer's strategy for making quartersawn wood.) Quartersawn wood has distinct, wonderful properties, not only being more stable as you work with it, but also showing wonderful patterns in the grain that would not be seen in wood that's flat-sawn. Otto Salomon's 1892 book *The Teacher's Hand-Book of Slöjd* offered insight into the character of wood:

"When a tree stem is sawn up into planks by parallel longitudinal cuts the planks shrink as shown in figure 4. The broadest portion shown, which includes the pith, shrinks least in thickness and most in breadth; least nearest the pith, most near the sides. The outermost plank, however, shrinks most in breadth—in the direction of the annual layers—and least in thickness. The planks lying between shrink differently on different sides and become concave to the pith and convex on the other side.

Fig. 4. Shrinkage in planks.

From Otto Salomon's *The Teacher's Hand-Book of Slöjd*
(Boston: Silver, Burdett, 1904).

"Cracks occur in timber, because, as indicated above, it is seldom uniform in texture and it is therefore liable to shrink in different degrees during seasoning. The more rapidly wood dries the more it cracks, consequently timber should always be dried very slowly to prevent formation of cracks.

"The swelling or expansion of timber, takes place when it is exposed to damp air or water and is in direct relation to its shrinkage.

When a piece of dried wood is immersed in water, it swells until it occupies the same volume as it occupied in its fresh condition, after which no further expansion takes place."

People may change a bit. Tools and techniques we use may alter somewhat in time. The attributes of wood do not.

In my own work, knowing that wood has its own story to tell has led me to make better use of its knots and imperfections. At an earlier time, I avoided such blemishes, thinking they would mar the customer's appreciation of my work. I have since learned that my customers appreciate the natural world, flaws and all. Perhaps that's because they've become weary of machined perfection and have developed a longing for more natural things. We need not compete with the perfection of the machine world, as we may be ill-suited to dwell in a place in which there's little spirit of wilderness and of humanity. I've learned this lesson, and to take a less critical view of my own work and the work done by others.

Seeking to find a balance between what I can say of the wood and what the wood can say for itself, I attempt to follow some guidelines. You'll find it useful to set guidelines of your own. Borrow mine if they suit you. In order to use my craftsmanship to best effect:

I strive to use woods that are sustainably harvested from my local area and present them in their natural colors.

I make use of natural edges and textures to enhance design.

I attempt to use the technical and aesthetic properties of various woods to their best advantage in the work.

I attempt to make useful work that will last for generations.

In signing my work, I identify the types of woods used so that others may learn to recognize them and know their beauty and value.

I make certain that by-products of my work are recycled to best use.

Through creating useful beauty, I offer homage to the spirit of the trees that have taken part in my work.

I suggest that readers hoping to build a life of craftsmanship choose a course and stick with it. Determine and choose your own set of values. What things are important to you that you want your use of a given material to express? While there are many beautiful species of wood from all over the world, some more beautiful than those that are grown in Arkansas, working with Arkansas hardwoods gave me a distinct advantage (beyond Governor Clinton's buying a few boxes to disperse in his travels). My work became of interest to folks visiting our state. I see trees growing in my own area to replenish what I have used and feel assured they will continue to grow here for future generations. My dedication to the use of these woods provides me with a sense of direction and suggests a down-to-earth quality in my work.

In my own work I've found no growing indifference or overfamiliarity when it comes to our Ozark hardwoods. Perhaps people have grown unfamiliar with these woods. There are so many lovely tree species in the world that would be considered far more beautiful and exotic than these. But what we have here is what we have, and even a plain piece of wood can be an entry point into a world of scientific and ecological wonder. The natural forest is a blend of species, each one contributing to the environmental quality of my home and yours. When we had a very late spring freeze a few years back, killing all the early leaves on our oak trees and robbing them of the chance to make acorns for that year, there were other trees that came forward to make certain the squirrels, deer, and wild turkeys were fed.

The Ozark forests have understory trees like the dogwood, Carolina buckthorn, and buckeye. Then there are the tall overstory trees. There are shade-tolerant species that grow up in an undisturbed forest, and shade-intolerant trees that step in to make certain cleared land does not remain unfruitful for long.

On my first trip to Nations Hardwood Company I was introduced to spalted woods. I was amazed at the dark lines and colors produced by the attack of fungi on dead and diseased wood. Seeing my eyes come to light, owner Claude Nations gave me a piece of spalted birch to carry home. Later, I began using thin slices of spalted maple,

sycamore, and pecan as inlays in the lids of my boxes. People in my community, realizing that I had a use for it, began bringing it my way. Once a woman called me about a maple tree that had been struck by lightning and caught fire. The fire department had quickly put it out and cut it down, leaving the tree's trunk and large branches in her front yard. Feeling that the tree was an old friend, she did not want it to go to waste. Two days later the tree was unloaded in my yard and ready for milling. That's the kind of thing that can happen when you love wood and your friends know it.

Spalted woods were first made popular by woodturners. While the old sawyers in Arkansas called such woods "doty," both terms mean wood that is partially decayed. The sawyer would have thrown it out as useless, but woodturners recognized its rare beauty that comes from the process of decay. A friend of mine in Oregon, Sara Robinson, has developed a scientific means of spalting your own woods, and she teaches woodworkers to do it.[4] But it's better to just discover pieces of it yourself.

If anyone has doubts about the value of teaching woodworking in schools or promoting woodworking as a way to preserve and protect the environment, you need look no further than the ways in which the use of wood can excite an interest in nature. I've two books to recommend. The first is Eric Sloane's *A Reverence for Wood*. It is a classic that should be read by every child in middle school. It carries the reader into a better appreciation of our diverse species and the stories that wood can tell. The second is *Trees of Arkansas* by Dwight Moore. Many of the trees in it are found throughout the East Coast and Midwest. The book not only tells how to identify various trees, but also describes the traditional uses of their woods. When you know the use for something, you know better that it has value and, in your imagination, at least, can see it being shaped in your own hands to build a better life.

When I teach classes in box making, I ask my students to bring a piece of wood from home. I tell them it should be something that appeals to them for some reason or other, and something that they

have selected themselves. My reason for these requests is that when the student has personally selected a piece of material they will use, it is inevitable that their work will offer something unique to them and that no two students' works will be exactly alike. At what better point can we start a project than with selecting wood? This approach works well for me because it was my own love of wood that got me started in my work.

Materials (your choice of materials, your understanding of materials) and where you start with them (whether you've processed the material yourself or you've purchased it from the supply chain) affect your feelings of agency and self-actualization, your sense of control over your creative process. They may also affect your feelings for your finished work.

There's a layer of clay under a steep road near my home. Years ago, a man discovered it when he sank his 4x4 pickup truck to its axles in it. If I were so inclined, I could dig that clay directly from the earth at my feet. It's not far below the surface. I could sift it and wedge it, then form vessels from it, heat them cherry red in a kiln I could build myself (I did that in an earlier time), and reenter my early life as a potter. I'd not make a living from it. We could call it an experiment. As a young potter, I felt that once the feel of the clay and of the process of throwing pots had passed through my fingers up into my arms and mind, that I could always repeat it, though I'd been apart from it for a hundred years. I'm no longer certain that's so, but what is certain is that I would be nourished in heart and soul by becoming more deeply connected to the natural world that surrounds me.

Educator Richard Louv has written extensively on the subject of "nature-deficit disorder" and the damage we are doing to ourselves and our kids by keeping under housebound and school-bound sequestration from the natural world.[5] We've become estranged, and we feel it. There are real physical and mental consequences from our detachment from the materiality of our world. Some of the distresses of the modern age include high blood pressure, depression, anxiety, anger, and loneliness. Time in nature and in the materiality of the world is

the proven cure. Engagement in this materiality offers rewards that our digital world does not.

The simple point is that the materials we use to create useful beauty in our lives are not simple. While I've been telling of my own deep affair with wood, the other materials of civilization offer the same depth. We grow into a relationship with them over a period of time. As we go deep—and *if* we go deep—into the materials of our craft we learn more about ourselves and the world around us. Materials become the means by which our innate creativity is exercised for the betterment of all.

CHAPTER 2

TOOLS

"It is tempting, if the only tool you have is a hammer, to treat everything as if it were a nail."

—ABRAHAM MASLOW

Throughout human history we have used tools to shape our natural environment, and in turn our use of tools has given shape to our human intellect, our perceptions of reality, and our understanding of ourselves. As sociologist Ivan Illich wrote:

"To the degree that [an individual] masters his tools, he can invest the world with his meaning; to the degree that he is mastered by his tools, the shape of the tool determines his self-image."[6]

"MY TOOLS ARE MY FRIENDS"

"I earn my living with tools. Every day I depend upon them to turn out the kind of work that brings more jobs my way.

My advice to anyone who works with tools as a hobby is to buy only the best. Regardless of how skillful you are, you can always do it easier and better with good tools — my choice has always been Stanley Tools.

Incidentally I have just read the Stanley Booklet 'The Joy of Accomplishment.' It offers a lot of help to anyone who wants to carefully select good tools for his home workshop."

IT'S FREE!

Send for a copy of "The Joy of Accomplishment" for yourself or for any of your friends who might be interested in the fascinating hobby of woodworking.

STANLEY TOOLS
New Britain, Conn.

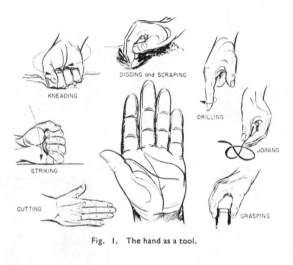

Fig. 1. The hand as a tool.

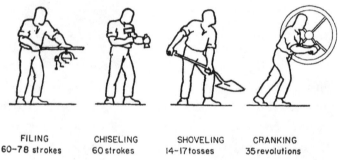

| FILING | CHISELING | SHOVELING | CRANKING |
| 60–78 strokes | 60 strokes | 14–17 tosses | 35 revolutions |

Fig. 16. Optimum work tempo.

As shown by these drawings from Rudolfs J. Drillis, "Folk Norms and Biomechanics," the hands have been the fundamental means through which the world has been shaped, measured, studied, and understood.[7] All the actions of tools are derived from the motions of the human hand. Our hands are also the means by which we test the substance of the physical world and come to an understanding of our place within it. With our hands, we measure the temperature, the weight, and the shape of things and whether they are coarse or smooth. So, the hands are not only instruments of creativity; they are also sensing devices without which our understanding of our world would be incomplete.

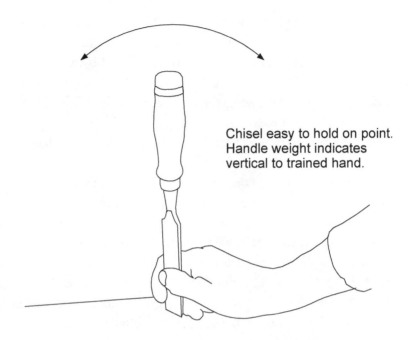

Chisel easy to hold on point.
Handle weight indicates
vertical to trained hand.

Hand sense is illustrated in this example. One would commonly think that handles are where you put your hands, but my experience with chisels suggests a different and more effective grip for some tasks. By placing your hand low on the blade, you gain better control of the position of the tip, your chisel-holding hand can rest on the working surface, and the handle itself functions as a pendulum, indicating if the chisel is being held exactly vertical. With your hand held low at the tip, it's easy to drag the chisel into exact position and hold it there in the ready for your first strike with a mallet. Try that while holding the chisel at the handle and you'll find your accuracy comes only with much greater attention and effort.

Charles H. Ham wrote in 1886, "The axe, the saw, the plane, the hammer, the square, the chisel, and the file. These are the universal tools of the arts, and the modern machine-shop is an aggregation of these rendered automatic and driven by steam."[8] Machines set our work to speeds beyond the traditional pace of the human body. We

may get things done faster with them, but possibly with less joy, and certainly with less effort and with less skill being required of us.

One of the nice things about a common shovel is that a common person can usually afford one or borrow one and can put it down when the digging is done with no greater sacrifice to their life. But if you buy yourself a backhoe, you'll no doubt need a bank loan, and after learning how to safely use it you'll be digging ditches at least until the machine is paid off. That may be great if that's what you intended. I tell this as a cautionary tale. Choose what you want to do first and use that as a guide to your gradual accumulation of tools. Keep what Ivan Illich has written about conviviality in mind: "Convivial tools are those which give each person who uses them the greatest opportunity to enrich the environment with the fruits of his or her vision."[9]

After my first book, *Creating Beautiful Boxes with Inlay Techniques*, was published in 1997, I got an email from a concerned reader. He told me he was meeting his new father-in-law for the first time, and he wanted to present the man with a box he had made himself. To prepare for his adventure he looked through my book and selected the box he wanted to make. It was a walnut box with mitered finger joints and a maple banding inlaid along the top edge of each side. It was also a hinged box, introducing an additional challenge. Inside the box was a set of dividers.

Having selected the ideal box, he began ordering tools. UPS delivered box after box to duplicate every tool he'd seen me use in the book. Now, two weeks before the arrival of his new father-in-law, he hoped to get started and finished in time. Realizing he knew nothing about how to use the new tools, or how to come to a thorough and safe understanding of their use, or how any one of them might fit the awkwardness of his beginner's hands, he wrote me for help.

It is only through practice that a tool becomes a seamless extension of your mind. Through practice, the hand learns to sense the cutting edge, whether it is used as a saw, knife, chisel, or plane. The experienced hand/mind quickly adapts to each. With practice and familiarity, the tool disappears from the demands of the conscious mind. When you pick up a tool for the first time, a great deal of your mind's

processing power and the neural network in your hands and arms is required. After applying hours of practice, the knife or chisel begins to fall into a familiar neural arrangement. It is good that this is so, as it allows you to do amazing things without the excessive preoccupations of your mind.

Playing a musical instrument serves as an example of this. Using a magnetic resonance imaging (MRI) machine, researchers tested both amateur and skilled pianists to observe the neural activity in their brains as they performed music on a keyboard.[10] The less skilled and less practiced among them showed an explosion of neural activity within their brains, while the more skilled and practiced pianists' neural activity was less perceptible on the MRI, thus showing greater ease in their performances. I suspect that with experience, the cognitive burden in doing a wide variety of things shifts from the brain to the senses inhabiting the musculature of the human body, thus easing and sometimes erasing the burdens of thought. You can test it yourself. Practice something that's demanding and watch it become easier over time.

Here is an experiment you can try. Any new tool will do, powered or otherwise. Pick one up and use it for the first time. Aim it toward the material you choose to craft. Observe the results, not just on the material, but on your mind and thoughts as well. You may feel it to be awkward at first, as your hand seeks to get comfortable with its grip. As a teacher, I witness students' first efforts at using a new tool. It can be awkward for them as they learn how to get just the right grip. Later, and with practice, they pick the thing up and go right to work. We each have the same need to establish a relationship with each of our tools. Necessary partnerships between each tool, our brains, and our hands exist in every craft.

It's not enough to witness this relationship in a video or through photos in a book without practice. It is particularly important to keep this in mind when first starting out. Do not allow yourself to become overly frustrated (some frustration is necessary for growth). The education of your hands, unless you start out very young, can take a long time. Be patient with yourself. To grasp something in the mind can take

place fast. To get a firm grip with the hands takes practice. And when the hands develop a firm grip, the mind's grasp becomes even stronger.

So, my reader wanting to make a box for his father-in-law would have a learning curve involving not only what he could decipher from the pages of my book and absorb in his mind, but also what he could feel and absorb in his hands. The time needed to develop a relationship between each tool and our hands and bodies can be an obstacle to immediate gratification.

One of the important lessons learned through the acquisition of skilled hands is to look at your own experience as your source of authority rather than adhering to beliefs contrived secondhand or thirdhand. For instance, I've seen on the internet many demonstrations of the use of chisels that create difficulties for the audience. Relying on what you feel with your hands is often of greater value than what you've seen or what you've been told to think. And coming to that point involves practice and close observation.

I suggested to my reader that the projects in my book were laid out in sequence from simple to complex ones, and that he might want to start with a project earlier in the book. Before getting to the box he had selected, there were seven chapters of boxes that would have built up his skills before his crucial deadline. The box he wanted to make could have been made in a day or two if he had learned the preparatory skills to make it. I do not know how his story ended. I hope he made the box and that his father-in-law was impressed, if not by the perfection of the box, then by the sincerity of his new son-in-law's effort.

"Tacit knowledge," a term attributed to philosopher Michael Polanyi, consists of those things that we know instinctively or that we have learned from example, experience, or observation without their having been communicated in a purely academic or intellectualized form. A woodworker with prior experience could have gathered enough information from the pictures and descriptions in my book to have made the box without needing to contact me. An even more experienced woodworker might have been able to ignore most of the written text and make the box from the drawings, a photo or two

of some of the more difficult steps, and the cut list that described the dimensions of the various parts. This specific reader contacted me because, without an underlying foundation of tacit knowledge, he needed help. But the help he needed was not something I could supply with more words, regardless of how many thousands I might deliver. The knowledge he needed would be something he would find through practice in his own hands and in his own body.

Polanyi wrote in *The Tacit Dimension*, "We should start from the fact that we can know more than we can tell."[11]

The idea that human knowledge is brain based or language based does not provide an accurate view of who we are and how we learn. This is not to disparage the brain or language, but to point out the necessity of a whole body/mind approach to crafts and to life itself. As described by Matthew B. Crawford in *The World beyond Your Head*,

> "There is a very real sense in which a tool may be integrated into one's body, for one who has become expert in using the tool. There are a growing number of studies that support this idea of 'cognitive extension'; the new capacities added by tools and prosthetics become indistinguishable from those of the natural human body, in terms of how they are treated by the brain that organizes our actions and perceptions."[12]

Polanyi described an example of a blind man tapping a stick in front of him to get a sense of his path. As a novice, he would likely feel every vibration as the same in his hand, but as he gained greater sensitivity in the stick's use, the combination of stick and hand would give him a more profound view, felt not in the hand so much as at the very tip of the stick itself. A hand tool is both a means of shaping material and a means to assess progress through the sensory information passed into the hands during its use. The chisel grip described previously acts upon the material and assists the eyes and mind in sensing the progress and assessing the results. The tool itself becomes transparent to the mind.

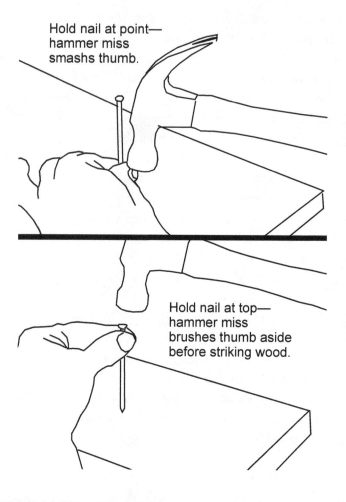

Hold nail at point—
hammer miss
smashs thumb.

Hold nail at top—
hammer miss
brushes thumb aside
before striking wood.

Throughout most of human history, children were introduced to the use of tools by parents and other family members. For many children in our digital age that is no longer the case. Even tools as seemingly simple as hammers and scissors are more complex than one might think, as evidenced by a college professor who told me of the awkwardness her first-year students displayed when asked to use scissors in a design class. Parents, let this book serve as an invitation. Introduce your children to the use of tools, such as hammers and scissors, that allow them to safely explore the materiality of life and their own creative inclinations.

Even tools as simple as a hammer require thoughtful body/mind coordination. The two simple drawings on the previous page would have helped me avoid smashing my thumb the first time my dad started me using a hammer. As a professional woodworker, I've tried to avoid using nails, preferring more sophisticated means for joining wood. But I frequently teach kids to use nails in building things, and this lesson is a help to them.

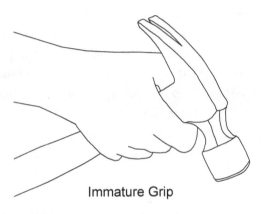

Immature Grip

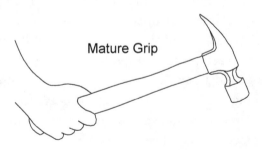

Mature Grip

Hand is positioned at end of handle.

When they first use a hammer, children (and some adults) hold it at its head. As the child matures and gains greater control, their hand moves down the length of the handle and their striking force vastly improves. With practice, as the hammer becomes a through-the-hand

extension of their mind, they do not lose accuracy as they gain leverage. Left with a hammer and the opportunity to watch others using one, novices will shift from the immature grip to the mature grip regardless of instruction. You can learn things such as this by observing your own tool use or by receiving careful instruction from others and then testing what you've been told.

Recognize that you have two hands, and that can make it difficult to do three things at a time. For instance, in using nails to attach two pieces of wood, you start out with a nail in one hand and the hammer in the other. If you then try to hold two pieces of wood together for nailing at the same time you hold the hammer in one hand and the nail in the other, you're trying to do too much. Instead, hammer the nail partway into one piece of wood, and then, when it's deep enough that it no longer needs to be held, align the parts that are to be joined, hold them in place, and hammer away. Doing only two things at a time applies to many other tasks in the tool-using crafts, and of course that's why vises and various forms of clamps were invented.

Tools can create a sense of agency in their using. For instance, I have a power planer. I stick the wood in rough and it comes out the other side smooth. It gives me satisfaction to be able to get a lot of work done in a less mindful manner. Using the planer could become a mindless exercise, but I avoid that by slowing myself down enough to carefully observe each piece as it goes in and is grabbed firmly by the infeed rollers. And I pay the same attention as it comes out the other side, checking for imperfections. The process feels particularly powerful when I remember that such tools were not commonly available to woodworkers a hundred years ago, when planing wood would have been done by hand. This delight in using a power tool does not contradict the pleasure you can find in handwork; the more effort you invest in your tool work, the greater the sense of satisfaction you might receive. Finding a balance between handwork and machine work allows me to have some quiet time in the woodshop and to hone

skills that I would not have using power tools alone. It also allows me to commune more closely with wood.

With hand tools you feel the work as it takes place, the vibrations that Polanyi and Crawford alluded to. And the slower pace of the work offers greater opportunity for reflection and contemplation. Having found a balance between machines and hand tools has given a better balance to my life.

I have a favorite Zen saying: "Poverty is your greatest treasure. Never trade it for an easy life." This saying goes counter to the natural acquisitiveness of the craftsperson perusing the latest catalog that arrives in the mail or the latest gadget advertised online. We see stuff and want it if it promises to make things easy for us or give us faster, more accurate work and require less effort and thought. We like smart tools that alleviate the need to become smart ourselves. This is certainly true of our digital age. We love smart programs and smart devices, failing to note that we become less smart and more dependent on what lies outside our own mental grasp.

I'm reminded of a scene in Ray Bradbury's novel *Fahrenheit 451* in which secretive booklovers spend months and even years reciting books word for word, anchoring each single word indelibly in their memory with the recitation. Sure, that was mid-century fiction, but I can guarantee the story would be even less likely to happen today.

We've developed an insatiable appetite for new things, which often runs counter to our actual needs. And we need to be wary of new things. There's an old saying that all tools leave their mark. Even hand planes used in woodworking to make a surface perfectly smooth leave subtle marks that have been described as "ligature." These are overlapping marks on wood left as evidence of the tool's use. It's a term used in other fields, including forensics.

In woodworking, we may use a plane to remove the marks left by a saw blade, and then use sandpaper or a scraper to remove the marks left by the plane. The right sequence of tools may erase the markings left by each previous tool. And yet the tools we use leave their marks

on the woodworker as well, most certainly on the design of the things and the pleasure we feel in what we've accomplished. It makes sense to choose tools wisely and with caution and not chase every pretty tool showing up in tool catalogs.

A few years back the owner of a local antique store asked me to stop in and see a chair that he said was from the seventeenth century. That may not have been the case, and while I said nothing to dispel his certainty, what I found by looking underneath caused me to doubt his date. There was a big chunk missing from the inside surface of one of the seat frame parts. That cavity could hardly have been the result of hand tools commonly used in the seventeenth century, as no amount of human force could have removed such a large chunk. Removal would have taken extreme force, like that of a machine. A person working with hand tools would have paid attention to the wood grain. They would have turned the wood in the opposite direction to require less effort and to get better results. The mark on this chair told stories of its tools and its maker.

I advise caution in considering tools. Do the tools own you, or is ownership the other way around? Tools can certainly give you feelings of power and control over your environment after you've taken time to learn and adapt to their potentials. When it comes to my woodworking friends, some have simple shops and work primarily with hand tools, occasionally out-of-doors to enjoy a spring day. Others have extreme shops with tools geared to maximum efficiency of production. One friend, an amateur woodworker, built a huge shop. After visiting mine he confessed he was embarrassed to invite me to his because it was so far over the top, and he did little in it compared with me, as my shop was crowded and messy with work. I also corresponded with a man in Brooklyn who made boxes in his second bathroom, having no other space available to work.

My own first woodshop was in a garage attached to the side of my basement apartment in Eureka Springs. It was about 15 x 20 feet in size and had no front door. For $40 a month, I rented a substandard apartment. The woodshop was worse. I built a wall across the open front of the garage, put in a woodstove, and vented out the front wall

for when the weather got cold. With an open flame gas heater and no AC, it was a torture chamber for wood, pushing it from the extremes of wintertime dry to the heavy humidity of an Arkansas spring in short order. And there I spent the next six years, learning on the cheap how to do my best work under adverse circumstances with just the few tools I could afford. But the setup did allow me the freedom to learn.

A friend of mine used to sign his emails "Buy the best and cry only once." That's good advice if you can afford it. My tool collecting has been more judicious, driven by two things: poverty and location. In Eureka Springs, there are no fine woodworking tool suppliers where I can go and select what I want. So, if I felt I needed something in my early days, it involved either ordering by mail or phone and then waiting for the UPS truck to arrive with my order or settling for the very limited selection of tools from my local hardware store.

Knowing each tool leaves its own mark, I've tried to avoid some of the new things I find in catalogs. Succumbing to the new is a great way to join the herd, but not the best way to lead it. I'm reminded of a particular routing jig that promised a new distinctive and recognizable, though nontraditional, look. If it perfectly and easily did the same thing every time, it would make my work indistinct from work done by others who purchased it. There's a sense of disinterest that rises from repeated exposure to the known. And yet, there's no tiring of seeing high-quality work, particularly when it is made with traditional tools and techniques, and when craftspeople exercise real effort and skill to make it. Proceeding cautiously in the acquisition of new tools can lead you to a deeper exploration of what you already have. For instance, do I need a mortising machine when a simple jig and a plunge router will do the job just as well?

Early in my career I developed my system of making inlay boxes I sold through galleries and craft shows. A really marvelous tool came out a few years after, and at a craft show a man walked up, observed my boxes, and said, "I see you've got one of those new INCRA Jigs. He could not imagine there would be other easier and less-calculated ways to do what I did, and, having seen the jig in his catalogs, he made

an assumption I was using one. I did buy an INCRA Jig soon after, and it remained unused and unnecessary to me for years, up to this day. (Does some woodworker out there need an original INCRA Jig, still in its original box with instructions? I have one.) The INCRA Jig is, by the way, a marvelous tool that has been useful to many. I do not mean to offend its maker or those who've found it useful. But I try to avoid tools and jigs that affect my work's design so strongly that viewers (particularly other woodworkers) look at it and think I took an easy way out that is less dependent on my own skills and effort. And when I avoid the newfangled stuff in this manner, I'm often sent back to find new ways to use the tools I already have. I feel a sense of discovery in this process, rather than having things made easier for me by someone else's invention.

Preparing tools to do the work is one of those things that must be learned and from which pleasure can be derived. For example, sharpening one's tools is an important way to begin to feel a sense of mastery that then translates into confidence when the blade is brought to bear on wood. Fortunately, when it comes to sharpening, the same rules apply to a variety of tools. For instance, the knife, chisel, and plane all have a common cutting geometry, and if you learn the basics of keeping one of them sharp, you'll know the principles for keeping the others sharp as well, although the jigs you use for each may differ.

Three cutting edge tools:
sloyd knife, chisel and block plane illustrate
the evolution of technology.

In my early days as a craftsman, I was shy about my chisels. Having spent good money on them, I took great care in their sharpening, after I'd learned that art. I'd worry that too much sharpening would wear them out, but I've learned since that a good chisel, if used with care, can last a lifetime. Yet the tool is only as sharp as its user. As the philosopher Zhuangzi wrote, "A good cook need sharpen his blade but once a year. He cuts cleanly. An awkward cook sharpens his knife every month. He chops."[13]

There are several ways to test the sharpness of the steel's edge. Some craftspeople take a sharp blade and scalp hair from their arms. I've done this. It doesn't hurt, and the hair grows back for the next time you'll need it. Some test the blade on a thumbnail. If it digs rather than slides, it's sharp enough. If you look dead on at the tip of a dull knife or blade and squint, you can see a bit of light reflected back. On a truly sharp knife or blade, you'll see nothing but the cosmos, split and reflected equally from both sides, left and right. If you sharpen often enough, you'll get better at it and will know, even without testing the blade after the practiced steps you've taken, that it will be sharp enough.

Some of my adult students arrive to class with tool chests filled with the best tools money can buy. I understand that. There's pleasure to be found in holding a well-crafted tool. Using tools that you've adapted your hands and mind to fit can also offer comfort and confidence.

Artisans have been delivering unbelievable works for centuries with fewer and lesser-quality tools than we have today. There's a saying: "The poor craftsperson blames his tools." This could suggest you should buy good stuff, as it would give greater chance of success. But even with the best tools, any of us can make mistakes amounting to poor craftsmanship. We learn from our mistakes and get better at what we do. Some mistakes we make over and over again, and from that we learn the art of self-forgiveness.

I found some good advice in Ellis A. Davidson's 1875 book, *The Amateur House Carpenter*: "It is by far the better plan to supply the

necessity for additional tools as it arises, than to buy a 'good set,' containing so many and of such various forms, that the amateur is puzzled which to use first."[14] Acquiring an overly large set of tools can deter you from learning the full potential of the tools you may already have.

When I began woodworking—living far from a fine woodworking tool supplier and thinking about the long wait involved in ordering and receiving whatever I thought I needed—I attempted to make better use of what I had and consequently became more creative in the process. Excessive reliance on new stuff is an even greater problem today than it was when I began. Online shopping for and speedier fulfillment of insatiable desires create an almost irresistible barrier to creativity and growth. I now have a large collection of manufactured jigs, and I also have a wide variety of jigs I've made myself, some of which I designed or invented. Can you guess which ones get the most use in my shop, and which ones provide the greater satisfaction in their use? Those I've made cost so little that when I wear one out, I make another. Using them, I can make things easier, more accurate, and faster—not because I bought something and developed a dependency on someone else, but because I made it myself. There's great satisfaction in that. It is empowering, and it increases the amount of pleasure I find in my woodshop.

The wider and deeper the artisan's grasp on the materials, tools, and processes used in their work, the greater their opportunity for originality and recognition. I have always found pleasure in making tools for special purposes and in reshaping existing tools to do things they were not designed to do. I read of a carver who had inherited tools that his mentor had reshaped. He spent years discovering how his mentor had used the redesigned tools to make various cuts. The making of tools and the reshaping of tools can reflect your depth of engagement in the creative process. Is it best to let others invent and design the tools you need, or can you use your imagination and reap the greater reward of having discovered something on your own?

Educators have long advocated that the partnership between

hands and eyes is essential. In the 1870s, a widely supported move-ment to put tools in schools spread across the United States and around the world. Calvin M. Woodward of Washington University and John D. Runkle of the Massachusetts Institute of Technology led this effort. They had noticed that students growing up in urban environments were not being educated in hand skills and tool usage and were thereby handicapped in engineering and math. Charles H. Ham, in his 1886 book *Mind and Hand*, wrote of the ideal school in which "not only books, but tools are put into the hands of the pupil."[15] And in 1915, John Dewey and Evelyn Dewey described the effects of that kind of education in *Schools of To-morrow*:

> "In schools where the children are getting their knowledge by doing things, it is presented to them through all their senses and carried over into acts; it needs no feat of memory to retain what they find out; the muscles, sight, hearing, touch, and their own reasoning pro-cesses all combine to make the result part of the working equipment of the child."[16]

But promotion of teaching manual skills has faded. Policy makers came along, convincing us we should no longer have a manufacturing economy but a service economy. Even before we fell headlong into the digital age, it was widely proposed that all children should go to college whether they were interested in that or not.

In schools there's little that interests a child more than the intro-duction of a new tool. In the life of a craftsperson—at whatever level, beginner or pro—the response is nearly the same. Even when the new tool is one you don't own but that inspires you to rethink and discover new uses for the tools you already have, the response is the same.

Your self-image, or the image you select for yourself, will dictate the tools that you choose. In other words, choose your friends wisely and get to know them in full depth. Albert Einstein said that his pencil and he were smarter than he was. Good friends can carry us a long way.

CHAPTER 3

TECHNIQUE

"Philosophy lives in words, but truth and fact well up into our lives in ways that exceed verbal formulation. There is in the living act of perception always something that glimmers and twinkles and will not be caught, and for which reflection comes too late."

—WILLIAM JAMES

Materials and tools are relatively easy to find. Technique is what's hard. The importance of technique may not be in what it does for us, but in what it tells us about ourselves. It involves steps and processes that can be difficult to describe, even when supplemented by photos. The reason I write books and articles is that technique is difficult, and the challenge of technique is the primary reason students attend my classes.

While materials form one leg of craftwork and tools another, technique is the third leg for making a successful enterprise. When my reader had bought all the right materials and the right tools to make the box he wanted for his father-in-law, and the book to describe the techniques used, he still could not make the box because he had not had a reasonable amount of time to embody the techniques into his own experience through practice.

But time is not the only factor. Technique can be elusive. Even when you stand right next to a craftsperson, get a full explanation of what they're doing, and take every opportunity to ask questions, the process of getting your hands and body in position to do what the teacher has just done is not easy without a foundation of experience to prepare you. The important questions may not come until you are standing at the table saw ready to do just what was shown you moments before. When Geoffrey Chaucer said of craftsmanship, "The lyf so short, the craft so long to lerne, the' assay so hard, so sharp the conqueryinge,"[17] he was speaking in part about the *technique* of craft— not only about tools and materials, but also about how we adapt our hands and bodies to the processes, and about how we set our tools into motion to shape materials into a form that meets our needs and expresses our relationships to the worlds of both nature and humanity.

Then again, time *can* play an important role in developing technique. K. Anders Ericsson, a psychologist at Florida State University, proposed the ten-thousand-hour rule that was popularized by Malcolm Gladwell in his book *Outliers*. According to the rule, it takes ten thousand hours to become truly expert at something, whether playing chess, hockey, or viola or doing woodworking. Gladwell offered the Beatles and Bill Gates as examples. By the time Bill launched Microsoft, he'd spent many more than ten thousand hours programming computers. And before the Beatles hit the big time, they'd spent years working in clubs. Ericsson offered, as an example, two Hungarian educators, László and Klara Polgár, who homeschooled their three daughters to become top-ranked women's chess champions. The Polgárs wanted to challenge the notion that women couldn't succeed in fields like chess that require spatial thinking. Their youngest daughter became a grand master at age fifteen, having played chess for more than ten thousand hours.

By the time a child has completed high school, they will have been in school a total of 16,380 hours: 13 years times 180 days times 7 hours per day (provided they haven't gotten bored and dropped out). That's time enough to become expert at something and at least well

practiced at something else. But too many children learn that they don't like school much and that they find no passion for the subjects within it. They fill seats while their minds wander. Can you imagine what our schools might become if they were more clearly targeted toward the accomplishment of greater things that captured the interest and attention of each and every child?

You need not invest ten thousand hours in something you enjoy for it to change your life. MacArthur Fellow Bill Strickland, who had been a troubled youth, was being kept after school when he saw an art teacher sitting at a pottery wheel throwing a pot.[18] The teacher invited him to sit at the wheel and put his own hands on the clay, and this transformed Bill's life. A friend of mine became a professional potter, and later a chemical engineer, as a result of seeing a potter's demonstration at a shopping mall. His pottery led to his interest in formulating his own glazes, and that led to an interest in chemistry. As you see, there's magic in technique, particularly when you passionately combine it with the materials and tools involved in reaching through to your creative self. You should direct technique, and the time spent exercising it, toward the development of skills that are rewarding to your spirit.

My students come to class wanting a variety of things. Most have had some experience working with wood. Some have made boxes and struggled to get perfect mitered joints. Most want to learn woodworking joinery methods. Some have tried using hinges and need further help to get their installation just right. Others want to see how jigs are made and to learn how they can make the specific jigs that make their work easier, more consistent, and more accurate. Of course, jigs are themselves another form of tool, often made to hold stock in a particular position while acted upon by another tool. Some students want design help, or they may have an idea about a box they want to make but need help understanding the techniques required to bring it to a finished form.

For me, the opportunity to teach is valuable. A good friend who taught high school art for many years told me, "When you teach you

are paid to learn from other people's mistakes." But there's more to it than that. When my students challenge me and ask why something is done in some particular way, it forces me to think, reflect, reexamine, and then explain—and sometimes adjust—my own technique. Sometimes in teaching, my students find it difficult to do what I do, even while using the same jig and setup at the table saw. I try to describe not only what's obvious, but the things that are less obvious too. I say, "Watch how I hold my body, leaning slightly to the right as I make this cut." If I can get students to notice all the subtle things, their cuts can become as accurate as mine. Technique is not only a list of steps applied through certain tools or jigs, but also an adjustment in the human body, particularly in the hands, to the work.

If you want to become a better artisan, the key is to do more of your craft. But it's not just about spending time. Attention is required. In order to apply consistent, unwavering attention, you necessarily need passion. Outsiders often can't comprehend that passion and may misunderstand what the work entails. An anonymous poem tells a bit of this story:

The Potter

The potter stood at his daily work,
One patient foot on the ground;
The other with never slackening speed
Turning his swift wheel around.

Silent we stood beside him there,
Watching the restless knee,
'Til my friend said low, in pitying voice,
"How tired his foot must be!"

The potter never paused in his work,
Shaping the wondrous thing;
'Twas only a common flower pot,
But perfect in fashioning.

Slowly he raised his patient eyes,
With homely truth inspired;
"No, Marm, it isn't the foot that works,
The one that stands gets tired!"[19]

Another important aspect of technique is realizing that work is most easily accomplished through a thoughtful application of force. Give a beginning woodworker a chisel and they may want to drive it straight into the wood in a single whack. If their chisel does not go deep enough with a single blow, they may whack again, and again. They'll learn quickly that it won't work like that. They'll have to remove wood bit by bit to provide clearance for the chisel to go deeper into the cut. Experienced carpenters, cutting a mortise into the wood, will use the chisel to outline the cut and then remove the stock within in thin slices. As the work proceeds, the outline of the mortise must be cut deeper again and again and then shaved from other angles again and again until you meet the required depth. The harder the wood, the more you must go back and forth between the two types of cut. By dividing work into smaller increments, human beings can have tremendous power, but not without applying their minds to observe and reflect on the best techniques.

Woodworking philosopher David Pye, author of *The Nature and Art of Workmanship*, said there are two different kinds of workmanship: one of *certainty* and one of *risk*.[20] In workmanship of certainty, a craftsperson sets up machines and jigs to reach high levels of accuracy and efficiency, reducing from the process the need for attention and the opportunity for human error. In workmanship of risk, the craftsperson's complete and continuous attention is required, because if it wanders, the craftwork may fail. In an age in which machines do everything well, except for instilling personal value into things, Pye attempts to understand and explain the value of the craftsperson's work. He suggests, as I understand it, that things made through human attention require greater presence of mind and thereby offer growth to the individuals involved. There are values in that beyond

the dollars and cents of the object's worth. Machines, jigged machines especially, can sometimes be operated mindlessly, and do not offer many opportunities for growth to the craftsperson beyond their having set it up in the first place, if that was the case. Machines and jigged machines have the purpose of partially removing the necessity of skill and attention from labor.

There are times when avoiding machines and doing things the "hard way" may save time and money in the long run. After I had learned to cut dovetails by hand, I bought a router jig that promised to cut perfect dovetails that would appear hand-cut. I was facing some large furniture projects, and I hoped the new jig would make things easy for me. That would have been the case, except the hard maple I used for drawer sides made the router bit climb out of the router's collet, progressively deepening its cut, joint by joint, and messing up good lumber in the process. As a friend used to say, "Hurry up, so you'll have time to fix it later." It's a humorous warning, but when good lumber is messed up in the process of speeding things up a bit, more than time can be lost in the bargain. I still have the router jig. It's covered with a layer of dust. I keep its manual ready in case I choose again to use it, because there's no way to use it without refreshing my mind to the setup. But I need no manual to cut dovetails by hand. Having practiced this technique I know how to do it by heart, even when I've not done it in a while.

We can jig things up to the point that we've lost sense of the immediate value of human expression. My first post-college work was to operate a tool called a punch press. I would put a metal piece in a prescribed place on the tool (a die), press a pedal with my foot, and the top part of the machine would descend and press the metal part into the desired shape.

I had done so many things in crafts by that point, and at such an early age, that my hand skills were relatively good. I would stamp a part, quickly pry it hot from the die, toss it in a barrel, then put the next piece of metal in place, and push the pedal again as fast as you could say Jack Robinson. I had no idea what the parts I was making might fit, but knowing the bigger picture was not necessary to my employment.

One day a man with a clipboard, a tie, and a white shirt arrived to watch over my shoulder as I worked. He was timing my motions with a stopwatch and taking notes. When I stopped to get a fresh tray of unstamped parts he said, "You are really working fast. We'd do well to have more like you." And I said, "Sorry, this is my last day."

The practice and development of technique is one of the ways we replenish our humanity. Technique is about learning and growth. It is natural for each of us, even as small children, to crave opportunities to express our skill and expertise. For that, we crave an understanding of technique—not just that in our minds, but that which we feel in our hands and arms, the success of which we can measure with our eyes and touch.

So, what does it take to redesign your life to give yourself what you crave? Are there some societal jigs you can make for yourself and put in place? Let's think about that.

As you become deeply engaged in whatever craft you've chosen and practice it for a period of time, you will develop a catalog of techniques that can be useful in a variety of circumstances. For instance, I modified my technique of using spacers for a recent headboard project involving double biscuit joints. I'd practiced the technique with a very wide range of processes, from fitting hinges to the back of a box to cutting bridle joints and mortise and tenon joints on a table saw. While the specific technique is difficult to explain without photos and a lengthy description, using spacers made the difficult job of the headboard much easier. Having a catalog of techniques at the ready is one of the benefits of engaging in a particular area of work for a long time, something that most longtime artists and craftspeople will confirm if you ask them.

I can thank my Great-Aunt Allene in part for my interest in woodworking techniques. She had been an avid collector of antiques, and when she passed away she gave a lot of old stuff to all the children from my father's family. For my family there was a grandfather clock that had belonged to my actual grandfather, some finely crafted mahogany chairs, a mahogany dining set with a large expandable table, at least ten chairs, a large sideboard, and a matching china cabinet

with curved glass doors—all of which, it was claimed, had belonged to a governor of Iowa. I was given a walnut bed that supposedly belonged to my great-grandparents, and a tall English walnut secretary that was made in an Eastlake design. Living with and looking closely at that furniture awakened my sense of curiosity about how things were made, and particularly the joints that held things together. The Eastlake secretary had drawers made with a Knapp joint, named after the man who invented the machine to make it.

Living for a time with those old pieces of furniture, I gained an understanding that things made of wood could be made to last, even beyond the time of our own lives. It made sense to me that a bit of extra investment in the making of something could help it to last, and one of the factors that made things last was a successful woodworking joint.

Early on in my woodworking career, I set goals for myself to learn certain techniques that I regarded as essential. I then chose projects that gave me the opportunity to learn those techniques. For example, when my mother asked me to build a cradle for my sister's baby, her first grandchild, I chose to use bridle joints to build the box of the cradle, floating panels that were resawn and book-matched to gain the necessary lightness and width, and wedged mortise and tenon joints to allow the cradle's stand to be taken apart and stored. Along with practicing those joinery techniques, I refined my carving skills by hand carving a winged heart to swing from the top of the cradle.

When that cradle was completed, my mother asked me to make two more in the event that my other sisters would need them. So, there's a cradle tradition in my family that's moved on to new generations, based on a few techniques that I knew I needed to learn. I made three more cradles to sell and ended up with one that did not sell. My wife and I have passed that one around for years to the children and grandchildren of friends. Our own daughter slept in it, and if the time comes for her to have children it will be used again.

Once having learned those techniques, I set my sights on more. I developed a useful strategy to keep learning new things. Living in a small town, I could not afford to turn down much of the work that

came my way. Few of my customers understood the value of the techniques I felt the need to learn. Nor did they necessarily want to pay that much for them to be used. I began using discussions with my potential clients to describe the techniques I wanted to learn and why they would impart greater value to the work. That gave me a chance to educate them while I was also asking them for the opportunity to help me gain new expertise and attend to my own growth.

Remember this simple theory: start with what you know and find easy or simple, and then build from there. When you have a full set of techniques under your belt, you can make anything. In time, a whole catalog of techniques, both simple and complex, will be there for the craftsperson's work. Through practice, even complicated tasks will become easy for you.

Then, there's what a good friend calls the "law of parsimony." As you repeat again and again what you have learned, some of the steps that you believed necessary to that technique start dropping aside, leaving only that which is essential. So even after you've learned to use a particular technique, you're still learning, cutting away the unnecessary steps, refining your work, and acquiring greater ease with which the work takes place.

There's a natural tendency as you develop craftsmanship for new techniques to become more and more difficult and complex. This is led in part by your insistence on growing in your craft. If you view that evolution as a spiral spinning outward, you could illustrate it as centrifugal force, viewing it as we view the cosmos, with stars and galaxies spinning relentlessly apart and things growing ever more complex within it. Movement in the other direction, stemming from the desire to simplify and make whole, might be visualized as centripetal force, a spiral moving in the opposite direction, inward like gravity. The movement to simplify is often suggested as the "KISS" principle, rudely stated as "keep it simple, stupid." The word "stupid" is applied in recognition of human error, but as I regard error as fundamentally human, and not a cause for chastisement, we can drop the last "S." Inherent in complexity is an increase in the opportunity for error and disappointment, so stripping

away from one's procedures those unnecessary steps that can introduce error increases the probability of success.

Writing about my work has caused me to take a more critical view of my own techniques. Working with a camera to film instructional videos has made me question, "Is this the most efficient way to do this? Is this the safest way to do this?" Writing and teaching are very much of the same cloth, as in both, the teacher bears a responsibility to their audience. Writing about my work and teaching also invite me to explore new ways to do things that I can then share with my readers and students. There's a good reason why medical school students are told, "See one, do one, teach one," for teaching is one of the best ways to make certain we learn and grow and witness with certainty that we're on a path toward mastery.

There are two good ways to begin learning techniques as forms of knowledge. One is what's called *Wissenschaft* in the German language. The term describes knowledge that's gained secondhand or thirdhand rather than from one's own experience. Reading about a technique or watching something on YouTube or television are examples. The other way is called *Kenntnis* in German. *Kenntnis* refers to learning by doing—knowing what we know by having done something first-hand. It actually helps to take a balanced approach between the two. So, I became an early subscriber to *Fine Woodworking* magazine as a launching point. But I chose not to adhere too tightly to what various articles said, thus allowing myself to find my own way to a certain extent and discover a few things on my own.

There are still a few *Fine Woodworking* articles on innovative technique I remember clearly to this day. One in particular was by George Frank, a Hungarian-born wood finisher working in Paris after the First World War. He told the story of finishing the interior of a bank. On the day before it was to open, the architects visited and insisted that all the interior woodworking was finished in too light a color. There was no time to strip all the woodwork and redo it in a darker shade. At George's suggestion the workers set up Bunsen burners throughout the bank, placed a pan of ammonia on each one, and sealed the building. George, an avid student of chemistry, knew

that the ammonia fumes would darken the wood. The architects, the owners of the bank, and George's boss and coworkers were all impressed when they arrived the next morning. Aired out and with minor touch-ups, the bank opened on time. While I would not repeat this particular method today, I recall it when I'm trying to develop nonstandard techniques.

Of course, one reason this story stuck in my mind for so long was that it was told as an adventure. As a budding craftsman, I saw myself in George's place and felt the experience of his story. That kind of tale is deeper than just telling how to do something. It anchors the technique in the gut as well as in the mind. (That's a concept woodworking magazines would do well to remember today.) More of George's well-told stories of discovering new wood finishing techniques can be found in his book *Adventures in Wood Finishing*.

My woodworking students often ask me about the order of operations, or how to design a process step by step. I tell them it should read like a good story, leading you from point A to the point that you consider the work done. A good designer will start with an outcome in mind, look back toward a starting point, and fill in the blanks between, charting the steps forward and taking into consideration the characteristics of the materials, the tools that are available, and the understanding of technique, all of which are required in the finished work.

Let's look at one of my processes as an example. Since I make a lot of inlay, people sometimes give me small pieces of wood, thinking that since my inlay contains small pieces I may need lots of them to get started. In actual fact, I start out with boards that are large enough to handle safely through the various steps. Taking a small piece of wood and starting from that point would put my hands at unnecessary risk of injury, and I'd have no chance of ending up with the design I had in mind. So, my process in making inlay is this: I first take boards of various species of wood and rip them on a table saw to a width about 1.75 times greater than the inlay strip I want to build. The extra width makes allowance for the process waste (sawdust) that will come from sawing in a later step. Step two is to cut those boards into short pieces

about ¾ to ⅞ inches long and arrange the pieces, aligned end grain to end grain, into a pattern that intermixes the various species of wood. Using a flat board as my platform, I apply glue to the end of each piece, keeping them arranged in the pattern. I then use bar clamps to keep the pieces together as the glue sets. After the glue is dry, I pass the block of wood made up of the intermixed smaller blocks across the jointer and then rip it into thin strips on the table saw. Then I rearrange the strips to create a pattern that interests me, and I glue them back into a solid block. Finally, I rip inlay strips from that block to use in the lids of boxes. Note that at no time do I handle the very small pieces that show up in the finished inlay.

This technique I just described is important not only for making inlay, but also for making all the very small parts used in box making. Whatever your craft, do all your processing on bigger pieces, big enough to keep your hands safe, and then make the final work liberating your teeny-tiny part from bigger stock.

Something you may note: If you are a very experienced woodworker, you might understand the process for making the inlay from my text alone. If you are not a woodworker or are a less-experienced woodworker, you might need photos and captions or perhaps video to come to a better understanding of the process. But this process is what I imagined in my head the first night after arriving home with a load of Arkansas woods from Nations Hardwood Company. I could see the steps in my head, which is actually better for me than seeing photographs.

Of course, we all have our own ways of learning. When I showed a drawn plan to one of my students, she protested, "I'm a visual learner." I said, "This is a visual plan." "Not that kind of visual," she said. "I'm a YouTube visual learner." Whatever your preference, as long as it gets you started learning techniques and discovering the creative power of your own hands, I'm all right with that. And the techniques that you'll remember best, of course, are the ones you have discovered on your own and witnessed in your own hands.

CHAPTER 4

DESIGN

"We follow a path of discovery, strung like pearls on a thread of curiosity, lending richness to our work."

—JAMES KRENOV

One of the challenges many artisans face and wonder about is finding your own distinct voice—what some call a "signature style"—that's recognizable to others and offers you the opportunity to gain recognition. You can point to various artists' works in any media that achieved such recognition. For examples, James Krenov's cabinets, Sam Maloof's rockers, and George Nakashima's tables are classics in woodworking design, frequently emulated and instantly recognizable. Shōji Hamada's tea bowls were becoming so widely copied that his patrons asked that he begin signing his work, which was not his practice. Having already become famous, he refused, suggesting that when he was dead and gone the best of his copyists' work would be thought his, and the worst of his would be thought theirs.

Being recognized for your work is fairly easy if you're the only woodworker in town or in your family, but a bit more of a challenge when you've launched yourself into the larger world of art fairs and

galleries. Success in these venues requires some degree of originality, meaning you'll have to design your own work. Even meeting the needs of friends and family may require more than copying works from books and articles. Earlier in this book I mentioned the narrative aspect of crafts. Just as the tree's growth is narrated in its grain, your own stories are told in the work you do. When you design your own work, you tell a story about how you see the world, and that vision reflects the values you find important. You then attempt to use your work not just to get done with it and make money from it but to share your values and your beliefs and to convey an understanding of who you are.

My own hands-on approach to my craft made me look at a couple things that were happening in the world that I felt required attention and mediation. One was that wood was undervalued as a resource, and the other was that modern life was leaving the hands of people, and the clarity that hands provide, out of the loop.

Recognizing that wood was undervalued led me to decisions that affect the signature style of my work. Some woodworkers make wide surfaces by gluing narrow boards together edge to edge, and they do so with some success. But out of a sense of reverence and appreciation for wood, I've preferred to use wide stock where possible rather than gluing up. My own view is that the cutting-board look of glued-up stock sacrifices some of the beauty and authenticity of natural wood. There are risks involved in my choice. A wide board is more likely to warp than a wide glued-up panel where attention is paid to alternate orientation of grain. But when I compare certainty with risk, my choice is obvious. There is a certainty that cutting and rearranging wide boards as narrow stock will diminish the beauty of the wood. There is a risk that wide boards may warp more than wide panels. My choice has been to give the wood a stronger and more authentic voice in the finished work.

The second realization that affects the look of my work, that modern life has been leaving people's hands out of the loop, appears in the wide range of things that have become inexplicable within our own

understandings of life. We see and use things—particularly advanced technologies—all the time that are sealed against our understanding. An example is that today's cars often have their motors sealed under large plastic shrouds, warning casual consumers who once felt entitled to do their own engine maintenance or repair, "Keep your hands off. You are not capable of understanding the parts sealed within." My response to that has been to make my work clear and comprehensible to the viewer. My decision to use joinery like dovetails and mortise and tenon joints that are visible rather than hidden gives the viewer a clear understanding of how this one thing works in a world increasingly obscure and incomprehensible. What they see may not enable them to do what I do, but it may at least provide them with a sense of what I've done. The additional unhidden benefits are that beautiful joinery is a delight to witness as a decorative element in the work and that seeing clearly what I've done in the making of a piece may increase a sense of its value.

These two design decisions are not original to my style. Nakashima was using wide planks in his tables around the time I was born, and thereby paying homage to the trees from which his lumber came. The work of James Krenov frequently made use of exposed joints expressing meticulous attention to detail and inducing the viewer to look closely and touch, even when touching was not allowed. In my work, the use of wide materials and the use of exposed comprehensible joinery techniques express my personal sense of authenticity, as does my preference for natural clear finishes that allow the natural beauty of the wood to come through. As these decisions are not my own inventions, you are welcome to use them yourself. The point is simple. Choose your design parameters to match your own disposition and beliefs. You are free to wander from your choices, but return and return again to your principles.

Educational psychologist and author Jerome S. Bruner offers another important lesson in finding one's way in design: balancing knowledge with surprise. For Bruner, the left and right hands symbolize two different ways of thinking and looking at the world:

"Since childhood, I have been enchanted by the fact and the symbolism of the right hand and the left—the one the doer, the other the dreamer. The right is order and lawfulness, *le droit*. Its beauties are those of geometry and taut implication. Reaching for knowledge with the right hand is science. Yet to say only that much of science is to overlook one of its excitements, for the great hypotheses of science are gifts carried in the left hand."[21]

The left hand is associated with the right brain, and the right hand with the left brain, those being among the wonders of human anatomy and subject for endless speculation. The left and right brains and the integration between the two are popular subjects in psychology and subjects that are not fully understood. But we know that the two hemispheres represent different ways of thinking about the world, with the right brain being generally more intuitive and the left generally more analytical. When I had my incident of midnight illumination that led to my making of inlay, my right brain conceivably played a major role in that.

One of Bruner's important concepts is that of "effective surprise," wherein a sudden left hand can deliver what he calls a "sucker punch." And while the purpose of design education is not to knock students off their feet, those things that elicit a state of surprise have a profound and powerful effect. I'm reminded of a fellow artist who, while tending her booth in craft shows, would sit quietly reading a book, paying little attention as crowds of people passed by. As she read, she would glance over the top of the page and watch feet passing by. When she saw feet stop and toes turn toward her work, she would look up from her book and engage her customer, knowing that they would be someone seriously interested in her work. She knew that turning toes illustrated a direct, physical response to some element of her work, and that deserved her own warm response. Surprise is often conveyed as a physiological effect, even as simple as the turning of toes. And as we go off into uncharted realms in our work, we hope to make true the saying, "I never cease to amaze me." That may come

from thinking outside the box and digging into your own passions to facilitate inspiration.

At the time I launched my career as a craftsman, first in clay and then in wood, I knew that it was important to let my creative imagination intrude. That happened the night I awakened knowing how to make inlay, and it's happened over and over again as I've struggled through technical problems that my daytime mind would not provide clarity to resolve. By listening to my right brain, I rarely cease to amaze myself.

A simple path for engaging both the left and right hands and all of the brain is being mindful of where you look for your inspiration. You may find good ideas by reading books and articles like those that I and many other craftspeople have written. But if you're seeking your own voice, have confidence to follow your own path. You'll discover things that are new to you and new to others also. Things will evolve in ways you may not expect. And discovery—what Bruner called "effective surprise"—calls your whole being to a heightened state of alertness, allowing for deep learning and even further discovery.

When you open yourself to the unexpected, you allow your unique experience to inspire fresh directions in your work. A story of one of my works illustrates this. I once came upon a picture of a magazine in which the center of the pages had been carefully cut away, and the hollowed-out spaces were occupied by loose rocks. Around the same time, I received a commission to build a table for a traveling museum exhibit celebrating Arkansan writers. Because the name of the exhibit was *The Lost Roads Project*, I chose to build the table in honor of Arkansas rivers, they being the first (yet forgotten) roads into all parts of the state. I gathered rocks that I had picked up on various canoe trips on Arkansas rivers and set them in a cavity (much as rocks sat in the pages of the magazine I had seen) along an artificial watercourse that flowed from one end of the table to the other. That table was my first work to make it onto the pages of *Fine Woodworking*. It landed on a page opposite an article celebrating the seventy-fifth birthday of famed woodworker James Krenov. I hoped that when he

saw his photo in the magazine, his eyes might shift to the other page and see my work.

A similar project, a custom project made for a contractor in Little Rock, illustrates the importance of narrative in establishing your own voice in your work. Narrative may be as strongly present in hand-crafted work as in speech and written discourse, and in some cases can be more powerful. While words may, as they say, "move in one ear and out the other," the sincerity invested in a well-crafted piece may linger and make a deeper impression. Our objects describe who we are, what we are learning, where we are going, and the means through which we will arrive at our greatest potential.

The narrative of this table—which I call a "River Table," due to its meander—describes the relationship between me and the man who commissioned the work. It records my own ambition toward quality work that also allows the wood to tell its own story. Each and every piece of handcrafted work is autobiographical in that it records and describes the character, understanding, and intentions of its maker, as well as recording their motions in making the piece.

This table connects typical and unusual elements in the same work. The contrast between the natural-edged top board and the slightly more conventional mortised and tenoned base is an example. While some viewers familiar with the process of crafting such work might know the sequence of operations the work records and describes, a casual viewer might instead skim or read the work sequentially, just as one might skim or read a published text. The meander cut through the center of the board is used symbolically in a fictional representation of a river or stream, while also allowing for the use of a traditional technique—the sliding dovetail joint. Small stones embedded in the top introduce an additional surprise and are used to disguise knots in the wood, with the grain radiating out from the knots as water ripples from a rock dropped in a stream. As this table shows, storytelling, the foundation of human culture, is not just something that happens through words alone, but can take place whenever the human hand goes to work.

A walnut and maple River Table.

I've continued to incorporate rocks in my work, both furniture and boxes, on occasion to this day. My point is not that every craft artist should incorporate rocks in what they do, but that you should open yourself to the use of the unexpected. Surprise is effective. It shapes the way you think, and it may bring attention to your work, at least for a time, until whatever concepts you express are no longer a surprise.

A great place to find surprises capable of influencing your work is your local museum. There you can find craft objects that were authentically made and that differ significantly from the commonplace. Certain pieces in museums may become your friends that you visit again and again. Let these works enter your dreams and see what surprises come. You might also look outside your own craft to other relationships in your life. Other hobbies, interests, and friends can inspire you. They are part of your own story, so it seems fitting that they become a part of the narrative told by your own work.

One way to work as a craftsperson is to simply use designs created by others—designs you've admired in museums or books. That's a great way to make beautiful and useful things, learn the use of various tools and techniques, and have a somewhat predictable outcome. It's the path many amateur or beginning craftspeople take, as there's less risk involved. Designing your own work is a bit more problematic and it entails a bit more risk, but it encourages your own creativity in ways that working from other folks' designs will not.

In most of my conversations with readers who've made things from my books and articles, they'll point out the changes they made to alter my design to be more suitable to their needs or the changes they made to alter my process due to differences in the tools they had available. Even changing the species of wood used in a project offers the amateur woodworker greater sense of agency in the outcome of the work. So, whether you're modifying a design or starting with a fresh design from the outset, originality is an area in which you can take pride and through which you will gain a more expressive voice.

When crafting work for others and trying to make a living from it, you will be faced with the challenge of designing new work or

altering existing designs, as very few customers will want something that others wanted previously. There are several factors involved in this. You'll need an understanding of how things fit together and how to make things that are useful, will fit the desired setting, and will last. Another consideration has to do with aesthetics. Each object made by a craftsperson expresses a wide range of relationships between physical, intellectual, emotional, and aesthetic realities. Much of this is never directly seen or understood by observers, but they often sense or interpret it in an unconscious manner.

A number of years back, an artist friend of mine introduced me to the principles and elements of design, which he had learned in art school. I find them useful as an analytical framework through which to look more critically at my own work and to help my students feel more confident in theirs. Many of the design principles are very natural to us, and you can be a good designer without giving them a further thought. The principles of design consist of unity, harmony, rhythm, contrast, proportion, balance, and visual illusion. The elements of design are lines, planes, shapes, focal point, color, texture, value, and space. I think of them as aesthetic tools that artists use to reach their design goals.

I'll not go through a major course in design here. Some artisans may study the principles and elements of design for years, while others may not need or want to go deeply into this theoretical, abstract realm. Where I find the principles and elements useful is that they remind me to use some of the tools that I may otherwise neglect. An example is the use of texture. For years it seemed that acclaimed woodworks had to be planed and sanded to perfection, but an awakening to the use of texture invited woodworkers to utilize natural edges and elements from the processing of the wood before it came into our hands. Examples are the marks left by a huge sawblade at the mill, or edges where the bark was removed to reveal interesting surface textures underneath. Line is another interesting tool for woodworkers. We realize that lines of grain are there for us to utilize in a sensitive manner. They can lift our work more than a notch or two, particularly when viewed by other artisans.

When teaching the principles and elements of design, I change one term. "Visual illusion" describes how a painter might convey 3D images on a 2D surface and thus create a narrative with the work. For those working already in 3D, such as a furniture maker or box maker, I substitute Bruner's "effective surprise." For surprising the viewer or user of a box with something outside the box brings them to a higher and deeper level of interest and engagement.

When I teach my students the principles and elements of design, I use a collection of my boxes to serve as illustrations, as it is so much easier to understand abstract concepts if one precedes the discussion with concrete objects. After making a number of pieces of furniture that incorporated stones embedded in the top, I taught a two-week box making class at the Center for Furniture Craftsmanship in Maine. In the evenings, I walked the beaches picking up wonderful rocks, which I then fitted in meandering cuts in the tops of boxes. I avoid gluing the rocks in place, thinking they should remain loose like puzzle pieces and fully accessible for examination. They were often a source of surprise to the unwary. As discovered by some of my students, if you pick up a lid and turn it upside down, you'll send the loose rocks scurrying across the floor. Many of my students wonder why I've not glued the rocks in place and leave them loose like that, but it was a great way to introduce the concept of effective surprise. And my students never dumped the same rocks twice.

I find the principles and elements of design useful not only for planning my work, but also for looking back and determining why some of the things I've made, even while unaware of the principles and elements, worked anyway. In some cases, they've simply given me more tools to instill a sense of playfulness in my work. They are additional resources for experimentation as an artisan works toward establishing a recognizable style of work. Play is what we did in kindergarten. Let's keep up the good work.

CHAPTER 5

LEARNING BY HAND

"If you would attain to the full intellectual stature of which you are capable, do not, I would say, neglect the physical education of the hand."

—SIR JAMES CRICHTON-BROWNE

Deep engagement with the hands as they are crafting has an effect on your sense of well-being that should not be ignored. In the early days in the Arkansas Ozark Mountains, men would gather in front of dry goods stores, whittling while their wives were inside shopping. Or they might make the trip into town without their wives, just to hang out. They might gossip about the affairs of their communities as they passed the time and as long, thin shavings of aromatic cedar and sassafras wood gathered at their feet. If you've not tried it, do. Make sure your knife is sharp. It's a skill that leads to a sharp mind. The whittling men of the Ozark Mountains may have been making only thin shavings of wood, and likely no product of value that they could sell, but they were also making sense of things.

Many amateur woodworkers, noting the therapeutic effects of time in the woodshop, call their hobby "sawdust therapy." The use of the word "sawdust" may be deceiving. For those engaged in woodworking, making lovely and useful things for family and friends creates much

more than sawdust. The engagement of the hands provides a liberation of mind.

The need to be soothed by our actions is not only a human trait. In the morning as I sit on the front porch and check correspondence and read the news on my laptop, my Goldendoodle, Rosie, slips away into the forest and comes back with a good chewing stick. As she carries the stick from the woods she prances, head and tail held high. As she chews the stick, she'll look up now and then from her serious labor to survey the yard for robins and the woods for squirrels, attending to them quickly if the need arises. The stick gets whittled down by her sharp teeth and powerful jaws. The mess she makes is a small price to pay for the satisfaction she expresses through her deep engagement.

Kelly Lambert, at the University of North Carolina, has spent years studying rats and their behavior to provide insight into mental health. She found that rats that work for their food exhibit fewer signs of anxiety and depression than those that don't. She also notes that animals of all kinds, including us humans, receive effort-based rewards in the form of pleasurable neurohormones when we engage deeply in doing things for ourselves and for others. She's even trained rats to drive tiny cars and found that the rats raised in an object-rich learning environment (the equivalent of a well-equipped kitchen or woodshop) learn to drive in less time. In addition, the rats receive the benefit of greater mental health as they manipulate their tiny cars to receive food rewards.[22]

For humans, to hold a tool in your hands is to hold the intelligence of generations that was applied toward its making and use. As Albert Einstein noted, we are indeed smarter with a pencil than we are without. When we take a tool into our hands and put it to use—even a tool as simple as a pencil or a knife, and even when the activity in using the tool is as simple as whittling a stick—we are raised in stature and well-being. To hold a knife suggests some degree of power in your own hands, even when you are somewhat inept in its use. Think of the chef at the chopping block, or the surgeon saving a life. Are they not raised in stature over the person holding nothing

but their hopes and wishes that they might have some sense of control over their own life?

I am reminded of a man who stood outside the wreckage of his home after the devastating earthquake in Haiti. With his wife and children trapped inside the rubble, he cried in despair and desperation, "I don't even have a hammer." I'm also reminded of a seven-year-old I saw holding a long stick at the top of a slide. He proclaimed, "It's a snake." Then he cried, "No, it's a sword," waving it against an invisible foe. Then he said, "No, it's an umbrella!" as he launched himself down the slide, holding the stick above his head. Try this for yourself. Hold a stick in your hands and feel your power return.

Susan Goldin-Meadow at the University of Chicago has found that the hand motion involved in gestures is not as meaningless as we've been led to believe. Even making simple gestures while talking allows us to better access and more fluently express our powers of speech and thought. She suggests that when you have trouble accessing a word, shake your hands and see what comes out.[23]

People have been made less intelligent and have sacrificed our mental health by refusing to recognize the integral relationship between our tools, our hands, and the creation of human intelligence. As neurologist and writer Frank R. Wilson noted:

> "The hand-brain system that came into being over the course of millions of years is responsible for the distinctive life and culture of human society.... Each of us, beginning at birth, is predisposed to engage our world and to develop our intelligence primarily through the agency of our hands."[24]

The idea that learning through our hands is essential might be considered an eight-hundred-pound sore thumb in academic circles. There are millions of people, college graduates and the recipients of advanced degrees, who feel justified in thinking themselves the best and brightest. For a woodworker in Arkansas to suggest that they could have been better and brighter if their hands had been more directly involved in

their education could be interpreted as an insult not because I said it, but because their failure to engage their hands in learning about and understanding the world that surrounds them may have left them in a precarious state of mind about their own capacities. After all, we've lived through generations in which hand skills were marginalized and the trades and academics were held apart from each other. These people may have compartmentalized learning to the extent that they see no irony in feeling smug about their accumulated book learning while being completely inept in managing even simple mechanical things. When it comes to fixing a toilet, for example, they call the plumber, thinking that because they know so little they might make a bigger mess of things. They should acknowledge at least a small bit of inadequacy in that.

Craftspeople too can compartmentalize learning, choosing to invest time and energy in particular areas of skill and expertise over others. That is a reasonable human trait, and it can benefit our work. The best of us learn to guard against losing a sense of wonder at the skills developed by others. We know firsthand the effort required to craft our own skill. We've thus learned the necessity of appreciating and encouraging the growth of others.

Otto Salomon, in discussing why Educational Sloyd was to be offered to all students, even those not destined to ever be required to develop hand skills, proposed the following:

> "Persons not manually trained, generally regard the products of manual labour at less than their real value. They think it much more difficult to solve a mathematical problem than to make a table. It is not an easy thing to make a parcel-pin or a pen-holder with accuracy, and when students have done these things they will be the better able to estimate comparatively the difficulty of making a table or chair; and what perhaps is of still greater importance, they will become qualified to decide between what is good and what is bad work."[25]

And Jonathan Baldwin Turner,[26] father of our nation's land grant colleges, wrote of the dangers of a two-tiered society in his Griggsville

Address, May 1850, noting the hazards of leaving one class of folks untrained in the manual arts.[27]

When you begin to understand the role of the hands in the creation of intelligence, you cannot help but notice the effects of current American education. To isolate the education of the mind from that of the hand and to separate those who have academic ambitions requiring college from those presumed ill-suited for academic pursuits and destined for the trades are costly decisions. Even those who may never need to fix a broken pipe might benefit from trying, and in doing so acquire respect for those who can. It feels good to figure things out and to witness the skills we've developed in our own hands. It feels good to know what to do next, and to then do it; and there are neurohormones involved that create a sense of agency and offer renewed energy to face those things that may ail us.

It is never too late to incorporate hands into learning. When my father-in-law turned eighty-two, I bought him a carving knife and sent it to him with the rough wooden shape of a small dog that he might whittle. After he opened his present, he kept the knife and carving blank in the box for about a month, and then one day he picked them up and went to work. From that day and for the next sixteen years, he didn't stop working on his next masterpiece. He set up a small workbench on his screened-in back porch. Using designs he traced on wood, he cut shapes with a coping saw and whittled small wooden animals that he gave as gifts to visiting children. My daughter has her own collection. I always knew what tool to buy him next. Over the sixteen years, he wore out a few knives. His carvings were not true masterpieces in the eyes of others, but they were a means of finding satisfaction and joy in their creation, and they were a way for a man to share. Need the carvings be or say something more?

We all feel the inclination to grow and develop in our own work. What we did last is not good enough in comparison with what we'll do next. That's the nature of growth and the spirit of craftsmanship. We do not know how high we might reach. We do our best, even

when the evidence of our labors is nothing more than the accumulation of aromatic shavings at our feet.

I told a sculptor friend of mine that I proudly wore the sprinklings of sawdust on my clothes, on the lenses of my glasses, and in my hair as evidence of my labor. I'd learned that evidence worn on the outside—just like the greasy hands, smudged faces, and filthy jeans of the tradesmen who came into my father's hardware store—is often evidence of meaning within. When we live lives of direct service to others, we feel better about ourselves and about each other. That's therapy of the best kind, and the hands are central to that.

CHAPTER 6

CRAFTING YOUR SELF

"Let the youth once learn to take a straight shaving off a plank, or draw a fine curve without faltering, or lay a brick level in its mortar, and he has learned a multitude of other matters which no lips of man could ever teach him."

—JOHN RUSKIN

Every act of making—whether in wood, metal, cloth, or clay—is a moral act, shaped by thought, belief, and desire. Craftspeople may not often think of such things, but as we go along crafting, making, selling, or giving our work, we perform moral acts with the power to transform not only our own lives but the lives of those around us. The crafting of an object is an expression of moral structure that likely predates any religious commandment or moral precept. We make objects with care, or we do not. We make them with an eye toward useful beauty, or we do not. We make them with the intention that they last, or we do not.

We make decisions that reflect our values, and in the act of making, we place those values on the line as expressions of their character and quality. Others can read and understand our values by examining the usefulness, beauty, and quality of the objects we've made.

To discuss the morality of craft, let me return to the hands and how they can open your mind to philosophical exploration. As your hands learn a skill, starting out as awkward as they can be, you require a great deal of mind and attention to control them. There is a constant feedback loop between your senses and the controlling structure and musculature of your hands and the processing power in your brain. As your control of your hand activity becomes more clearly established, some of the feedback loop moves from the foreground of thought to an unconscious realm. This liberates the processing power in your brain to engage in mind-wandering activities.

Anyone who has paid attention to the workings of their own consciousness can see the truth of this. A classic example is driving a car. Once you have mastered steering with your hands, your processing power is made available to carefully observe the road, plan your destination and what you'll do when you arrive, and even allow your mind to wander to things completely unrelated to driving the car.

The processing power of the mind that is liberated when the hand's work is mastered is the space in which philosophy is mastered as well. This is that opening of the mind that lies well beyond the idle, detached-from-reality speculations of traditional philosophy. In that space between the direct attentions that are required to complete a process and the proficiency that grows to allow the wandering exploration of the mind exists the potential for the development and expression of the human spirit.

In the relationship between the hands, mind, and materials, there is a rhythmic expansion and contraction of required attention in relation to the object you are making. By observing how your attention is balanced between the object and the normal tendencies for your mind to wander into other places and scenarios, you can attain a sense of your dual nature. You are given a choice: either follow your wandering mind until difficulties arise in making the object, forcing attention to return to the task at hand, or focus directly on the object, instilling a vital force of attention into its psychic structure.

Go back for a moment to driving a car. When cruising along a

narrow Arkansas roadway, the driver aims between the weeds growing at the right and the oncoming traffic in the opposing lane, so a balance between the two is required. The object of handwork is not to escape the consciousness the hands provide, but to achieve moderation. As a potter, I would sit at the wheel, with the clay centered and rising in my hands. If my mind wandered far from the work at hand the pot would wander also, becoming uncentered in response to my being uncentered. In the woodshop, cutting a curving line on the band saw, I observe the same relationship between hand and mind. Let my mind wander and the cut does also. The maker either can take the easy pathway of escape into fantasy until called back to reality by the materials being crafted, or can apply their attention continuously to making the thing while also maintaining an awareness of the higher purpose of making that's attended to by being present in the now. The first is the path of least resistance; the second is the path of the peaceful warrior/maker. The first describes making objects of practiced beauty. The second describes making objects with inexplicable radiance. How many of us can dwell in that perfect state? We are imperfect beings who strive toward greater perfection.

As a craftsman, I've always been drawn to learning things that set me apart and enable potential customers to discover interest in what I do. Craftspeople and artisans want challenges that allow them to demonstrate expertise and to set themselves apart from each other. This is the opposite of "progression" in, say, the digital world, where each new version is made successively more "user friendly." If an application gets easy enough to use, it can be used successfully by anyone, no special skills are required, and no student growth results.

The opportunities found in craftsmanship require us to do real things and develop real skills in the real world. There's a shallowness and artificiality if we think we're special because we can afford whatever is new in the tool catalog. There's also a shallowness that we've been trained to accept in thinking that our tools, in all their vast array, will make up for our failing to develop our inner lives.

In 1976, David Henry Feldman wrote an award-winning essay, "The Child as Craftsman," in which he noted that all children have, within their essential nature, a strong inclination to do something at which they have the opportunity to excel.[28] Feldman pointed out the attraction that children have for craftsmanship, which he described as the means through which each individual child works toward excellence.

Feldman offered the metaphor "the child as craftsman" as an alternative to prevailing models of education. One of those models is that children are empty vessels, and the teacher's job is to fill them with knowledge and understanding to the limits of their capacities. Another model, proposed by Jean Piaget, is that children learn and pass through marked stages, and the teacher's job is to provide lessons when the child arrives at each stage. Neither of these models touches fully upon the truth. Children, and adults as well, love learning. We love learning things that set us apart from others and through which others recognize our expertise.

Understanding the "child as craftsman" metaphor can set your life as a craftsperson on a new path. Instead of determining base-lines for performance, in which you hold yourself accountable to learn the same things in the same stages as everyone else and do not trust yourself to understand your own needs and desires, you would instead allow yourself to become a passionate learner awakened to your own inner life. In your life as an artisan, you would seek your own creative path.

You don't have to be an educational expert to observe whether or not a clay studio, woodshop, or other craft-learning center is fulfilling its mission. You see it in the engagement students demonstrate as they pursue individual passions. My sister Ann is an example of this kind of engagement. As a child, she was precocious in her abilities in drawing and in art. Her passion for drawing was such that her paper alone was not enough to contain her enthusiasm, and, with me on the floor drawing beside her, she would reach over and draw on mine as well. Ann went on to study art as her specialty in high school and college and became a designer of children's clothes and kitchens.

I, on the other hand, started out on an academic route and converted later to the arts. By the time my friend and mentor Jorgy told me my brains were in my hands, my own experience was hinting at the same thing. It was Jorgy's recognition of my re-creation of the soft top of a 1930 Ford Model A Tudor Sedan that led me to acknowledge that my hand skills and learning abilities might evolve to a point where I might develop further as an artisan.

Model A Fords had soft tops made with bent wooden top bows to support layers of chicken wire, cotton padding, and a leather-like rubberized material on top. These layers are neatly banded with a metal strip and painted with a thin version of roofing tar. The top bows were named for their bowed shape, and they had to have the correct curvature to look right and to shed water and keep it from pooling on top. The top bows on my Model A were in desperate need of replacement, so I used a table saw to cut thin strips of wood and used a sticky brown resorcinol glue to laminate the strips into the bowed form.

My mentor Jorgy, who had rebuilt and examined enough Model As and Model Ts to be an authority in the matter, judged my top bows "perfect." Bending wood into a permanent shape is something I've done hundreds of times since. We tend to gravitate toward areas in which we've had success. And we need to have many opportunities for various successes to choose from as we design our lives.

While structured classes are wonderful places to find such opportunities, we also need unorganized and unsupervised space in which we can discover new things and ourselves at the same time. A Finnish brain researcher, Matti Bergström, calls this "possibility space." He claims that children (and, by extension, adults) need a bit of chaos where they can test themselves and the world around them. He writes:

"The core of culture is art. The core of art is creativity. The core of creativity is possibility. The core of possibility is play. The core of play is chaos. Therefore, all culture is based on chaos. More than ever before do we wish to encourage each individual's creativity and culture-creating ability."[29]

Human culture must arise anew and be renewed within each generation. Our own personal growth, at whatever age we happen to be, is key to that. Yet seeking this growth by moving from the comfort of a predictable place to the volatility of a chaotic space can be stressful. Robert Brooks and Sam Goldstein—who study resiliency, motivation, and family relationships—write about the "islands of competence" that allow us to make this journey:

> "'Islands of competence' was not intended simply as a fanciful image but rather as a symbol of hope and respect, a reminder that all individuals have unique strengths and courage. If we can find and reinforce these areas of strength, we can create a powerful 'ripple effect' in which children and adults may be more willing to venture forth and confront situations that have been problematic."[30]

When we plan our own learning (or working) within narrow bounds, we limit our opportunity to discover our own islands of competence. We need to dance, move our bodies, and raise our voices in rhythm to music. As children we need to write in huge letters, setting our whole bodies in motion. As adults, we need to do likewise. We need to make useful, beautiful things that last centuries and secure meaningful relationships between home, school, history, the natural environment, and ourselves. We need to do real things that engage all our senses and provide islands of competence (and confidence) upon which to build our lives.

One of the things I like about the island metaphor is that islands are discovered. Having discovered an island, we soon after discover that it is part of an archipelago. Then next, like those who followed Christopher Columbus, we "discover" whole continents of knowledge and skill, ripe for learning.

Islands of competence can also be considered within the narrow bounds of a specific craft. What discrete activities within your discipline are you good at and take the greatest pleasure in? Do you like carving? Do you like sawing? Do you like planing or sanding things perfect to the touch? As did George Frank, do you like finishing? Just

as the inhabitants of the islands Columbus discovered did not need "discovery," your path will follow along similar pathways of personal conquest. You need not be good at every activity within your craft right off the bat. Use one success to build confidence for the next. Use the self-confidence derived from that as the launching point in the conquest of your next island.

Build skill after skill, knowing it can take time to develop expertise in the application of tools, materials, and techniques and to raise your standard of work. Years ago, The Taunton Press, publisher of *Fine Woodworking* magazine, began publishing a series called *Design Books*, which featured some of the best woodworking done in the United States. While I anxiously awaited each new volume that came out over the years, I also felt some dismay that my own work would not have measured up. I've increased my skills in the years since those days of dismay, and my work was eventually published in *Fine Woodworking*.

With woodworking and other crafts, the natural inclination is to get better and better at what you do in order to set yourself apart from others. Of course there is another inclination, which I've explored through meditation. A short time after I moved to Eureka Springs, I heard about Guy Loyd, a meditation teacher who a number of folks in town regarded as particularly wise. Folks seemed to know even then that we are connected in unseen ways, and I and others assumed that meditation might broaden our understanding of self. After visiting with Guy, a man thirty years my senior, I joined his meditation group. Folks came to his home on Sunday afternoons for discussion of metaphysical concepts, some simple instruction in meditation, and a group meditation session.

Guy was a retired engineer who also worked as a part-time woodworker, so we hit it off and became friends. His insight had a profound effect on my work. In discussing customers, he suggested I not think only of them and their needs as individuals, but that I should work for "the one." What was that "one"? Or should I ask, *who* is that "one"? He, she, or it was not proposed as some externalized being, but rather a wholeness that encompassed all, including me and my own growth

as a craftsman. I learned that we—like Columbus "discovering" first an island, then an archipelago, and then an enormity beyond—are not isolated beings. We are interconnected with others of our kind, and even with all things inhabiting this planet—humans, other animals, vegetables, and materials.

Guy's meditation instruction countered the craftsperson's notion to set themself apart from others. While craftsmanship could be a fulfillment of ego, Guy's meditation aimed in the other direction. On occasion folks joined the group wanting to prove themselves spiritually "superior" to others by seeking and using more advanced and complicated techniques. But Guy kept our meditation simple. We would sit comfortably in chairs and visualize our souls as a sun shining brightly slightly above our heads. There was no point in using meditation as just another form of one-upmanship. It was instead a way to quietly infuse our day-to-day living with a broader recognition of who we were as parts of a larger whole. And so those who hoped to use meditation as a way of proving their superiority over others quickly moved on.

The meditation, as simple as it was, had a powerful effect, helping me to feel more connected with my work and with others without the burden associated with feelings of superiority. My own craft, I learned, was a way to bring people together and help us each become better acquainted with the wonders we share.

One of Guy's favorite sayings was, "Energy follows thought." He suggested that when we think of something, we nourish it with the energy of thought, whether it's good or bad. He advised us not to squander our thoughts. In this I return to the philosopher in the workshop, which I discussed at the beginning of this chapter. The philosopher/craftsperson becomes a student of their hands and their attentions, and from that foundation explores the very nature of life and perception. When their mind wanders, they pull it back from whirling thoughts of common life to the task at hand or, failing that, onto the subjects of quality, beauty, and mindfulness and to the people with whom they share their work. Having heard of the peaceful

warrior/maker and having once seen them work, the philosopher is reluctant to squander their attentions on the mundane. This is not necessarily a difficult thing for artisans to grasp, as the ability to focus attention is an art that is shared by crafts and meditation.

Guy taught me another important lesson about what he called "dual awareness." We are bodies with individual responsibilities, but by choosing to focus not on ourselves but beyond ourselves with a larger, wiser, and wider view, we can discover greater meaning in life and greater connection with each other. This text by psychologist Howard Gruber is very much in alignment with Guy's advice concerning dual awareness:

> "To be effective, the artist must be able to step back from the canvas and ask, what have I made? How does this look, not only from my position one paintbrush-length away from the work, but also from other viewing distances?...
>
> "This obligation to move back and forth between radically different perspectives produces a deep tension in every creative life. In the course of ordinary development similar tensions begin to appear. What we mean by such terms as adaptation and adjustment is the resolution of these tensions. But that is not the path of the creative person. He or she must safeguard the distance and the specialness, live with the tension."[31]

Bergström offers additional insight:

> "*We evolve in order to unite the world we live in into a wholeness....* This is why the unifying force, the collective principle...assumes ever greater importance in our lives. It becomes apparent in our thirst for peace, accord, and harmony, goodness, a social and religious paradise, love of our fellow humans and nature and an ensouling of nature....We increasingly want the selective forces to serve the collective."[32]

My attempt to understand these ideas, and put Guy's dual aware-
ness into practice, was a way for me to feel engaged with a larger
world, even when I was working alone in my shop. It gave me an
excuse to think holistically, to see my work as something that had to
do with a much larger world beyond my own hands and my financial
situation, and to see my customers in a clear light. I began to feel I had
something of value to share, even as I struggled to get better at what I
did. For if I were part of something so grand as the universe itself, as
small and humble as I might be, I had a thing of value to share that
had holistic implications.

I can't prove a direct cause and effect between my meditation and
my craft, but I came to believe that customers were drawn to my work
not only by its quality and the story it tells, but also because they
recognized in me aspirations of their own. To put it in the language of
Zen, "Seekers of stillness are drawn to still waters."

Finding pleasure in friends who then became customers, or cus-
tomers who then became friends, has been the story of my life. It
does not take many customers to make a good life. There is a saying,
"Never mix business with pleasure," as though the two are to be kept
completely separable and distinct. That saying may make sense in the
corporate world, but not in craftsmanship. It is soon proven false, or at
least it certainly was in my own life.

Here is one example of this connectedness with my customers.
I built a trestle-style table for a customer who lived in a log cabin in
the woods next to a waterfall. The table was to fit in a special spot in
the kitchen at a window overlooking a viburnum bush teeming with
hummingbirds that perched for turns at the feeder right outside. The
cherry table that I'd been paid two hundred dollars to make was so
pleasing to my customer, he opened a two-hundred-dollar bottle of
wine so that we might celebrate together. It did not occur to me at the
time that I might have been better served by a cash tip of equal value.
I was working for "the one," and the money was not of a realm that
compared to the wonderful things I'd learned, or to the joy I'd felt in
the process of making the table and having my work celebrated in the

home of a friend. Those things were ample payment, for I was indeed working for the one.

Later, when my friends moved from the log cabin, they arranged for me to meet the owners of the property and to become its new caretaker. I paid $100 per month in rent there for years, and it was while I was living there that I met and married my wife. The setting was idyllic: An Arkansas log cabin with a 15-foot-high spring-fed waterfall outside the bedroom window. On our honeymoon of sorts we went nowhere. Where we were was beautiful enough.

The people who commission work from craftsmen when they have so many choices to do otherwise are very special. There have been many times when I've been asked by someone to make something they'd not seen before and that I'd not made before, and yet they've approached me with faith that I would deliver something to enrich their homes and their lives...all while they could have instead gone to a furniture store and had something delivered to do the same thing in the same day. I can tell you exactly what it means to the growth of an individual craftsman to have such faith placed in him or her, and through that to find a meaningful life. The implications on a personal level are enormous. Later, I'll discuss what meaning that kind of relationship has within communities and within human culture.

Earlier I mentioned that trees have their own stories to tell— where there's a knot there had been a branch and all that. What is our story to tell? Years ago, I attended an opening at a museum in which an artist gave a brief lecture on her work. I had walked through the exhibit before the lecture, trying to make sense of her creations. After her description of process and her motives for creating them, she asked us if the words about her work helped any of us to make sense of what we've seen. And, of course, that was the case.

If you were writing a novel, would you first develop a plot line that would help you keep on course and that, you would hope, your readers could follow? If you think of craft as being a form of narrative, can that help you to develop a plot? And does it raise questions? What is it you're trying to say? Is it meaningful to you, and do you think it will be

meaningful to others? Having a story line that's meaningful may help in developing work that says something more than "I did it!"—even though "I did it" is often enough. In fact, knowing the story line or plot of what you want to tell through your work will help to solidify what others recognize as your distinctive style.

In that story line, of course, authenticity matters. At the Nelson-Atkins Museum of Art, I watched an artist in a video go to work with a mallet and carving gouge on wood, crafting her large sculptural objects on display nearby and out in the museum yard. Then I went closer to examine the artist's work. Being a woodworker, I know what tools do and the marks they leave on wood. Discovering that there were no gouge marks, only the markings of a reciprocating saw, left me disappointed. This is not to suggest that the reciprocating saw was not a suitable tool for an artist's creations, but that honesty and authenticity in how you present your work is also important. Had the artist known that a woodworker familiar with tools would be examining her work, she might have actually used the gouge shown in the video on at least some parts of it, or in the video she might have been less deceptive about her work.

At best, each of us has our own story to tell. It helps to understand your audience. Who are you making for, and what message do you want to deliver, and is your work honest to your intent? These are the kinds of questions you begin to ask when your hands are busy and the skills of your hands have liberated your mind for its deliberations. So, think. What is the story you want your work to tell?

In my own case, I began with a couple themes that were somewhat related to each other. One was a desire to illustrate how things were made; the other was a desire to awaken folks to the beauty and value of Arkansas's native woods. These themes helped shape my relationship to my customers. I had noticed some were curious about how my inlays on my boxes were made. Even after I attempted to explain the simple processes to them, most folks did not easily understand. I had always been curious about how things were made, and because of my own curiosity, I was particularly drawn to types of joinery that could

be seen and understood. So, I chose to use more traditional joinery techniques, which my customers could immediately understand, visibly and proudly in my work. At the same time, I chose to use the Ozark Mountains hardwoods I'd come to appreciate and love in their natural colors and with the reverence I'd learned they deserve. I preferred clear finishes that showed the more natural colors of the various woods, and I showed a preference for wide materials over stock sawn and glued into strips. So, my use of visible joinery techniques and my reverence for wood became the narrative of my early work.

Sticking to this narrative, I began to build a body of work, including both my small inlaid boxes and other things that were recognizable to others because they were authentic to my own thoughts and objectives. As your hands develop skills, think about the story you and they can tell. Develop your own story line. Or borrow mine if you like. The story of our humanity is a shared one, and we gain strength in our telling of it. My own story will not be diminished by your telling it too.

CHAPTER 7

CRAFTING,
THE FAMILY

"The ground of this business [education] is, that sensual objects be rightly presented to the senses for fear that they not be received ... This is the foundation of all the rest; because we can neither act nor speak wisely, unless we first rightly understand all the things which are to be done and whereof we have to speak."

—JOHN AMOS COMENIUS[33]

Throughout the earlier times in human history and in every civilization, crafting was essential to survival. Children were taught by family members to make the essential things of life, and in doing so, culture was formed. In writing this book, I've tried not to be trite or trivial, and for that reason I have avoided clichés. But let's use a couple for good measure. The first is that apples tend not to fall far from the tree. I'm here now as I am because I've been delivered by trees of my own kind: a mother trained as a kindergarten teacher who loved the arts, and a father who loved making things and encouraging others to do the same. I bring them up not only as an explanation of who I am, but also because, as I'll address later, engagement with family at all ages is an important contributor toward personal artistic growth. Family is a thread that runs through this chapter of the book.

Second cliché: no artisan is an island unto themself. I have learned the simple lesson that you, I, family, community, human culture, and the world of nature are seamlessly interconnected, and, being connected, we have important things to learn and share with each other. We function best in our craftsmanship when we are deeply connected with others. Family for most woodworkers may be the most important source of inspiration and empowerment. When I ask my adult students where they found their own interest in woodworking, most will point to a close family member or to a school woodshop.

A third point, not common enough to be trite, is a saying from the *I Ching* (*Book of Changes*), a Chinese book of philosophy and divination: "If you want to know how something is going to turn out, look at its beginnings." I find that history tells us important lessons, which is why I've found value in looking back at such things as kindergarten and the manual-training movement. Coming from the opposite direction is a saying from the study of geology: "The present is the key to the past." We can witness elements of our own past as we watch craft traditions long held sacred in families and communities within the developing world being lost to manufactured market materialism. That plays out today even in the industrialized world as we choose to shop rather than to make for ourselves, our families, and our communities.

Let me briefly review the changing history of community-based crafts. For countless generations, locally produced home crafts met the needs of people. These home crafts were produced in family settings with skills passed on from generation to generation. They offered the potential of originality and innovation while also conforming to age-old traditions using locally available materials. People knew which local materials were best for what, and there was a demand not only to use them but also to protect them for future use.

For example, in the northern European countries, during the summer months, when there was an abundance of daylight, people gathered what they needed to subsist through the winter months. During the winter, when there was less light or no light at all, all the members

of the family kept busy crafting things that were important to their lives. They made their own clothing, farm implements, and tools, and most of the essentials for their daily lives. And from the earliest days of the Vikings, they were able to make additional income from what they crafted. Family, and bonds within the family, were key to survival and the means through which skills, knowledge, and culture were formed and passed from one generation to the next. This was the case not only in Scandinavian countries. It was a universal tale, and it was a far cry from the TikTok world of today. While modern youth are served by their parents with little expected of them, the youth of earlier times were given real work to do in their families and communities.

During the mid- to late nineteenth century, the developing world was in an accelerating state of flux as new industries and international trade rapidly grew. The sales of inexpensive consumer goods removed the need for locally produced crafts. Why would a Swedish mother make felted wool mittens for her son or daughter when leather gloves imported from Germany cost so little and were considered more stylish? (For that matter, why would an American mother buy her child a hammer when the iPhone is so powerful and offers no threat of damage to her Vietnamese-made furnishings?)

By the 1850s, reliance on homecrafts was rapidly subsiding throughout Sweden. Families could rely on external industries, no longer needing or wanting to craft items to fulfill their needs, and so no longer receiving the benefits of healing and wholeness that the engagement in crafting provides. Consequently, Sweden experienced rapid rises in alcoholism and in the psychological disorders of anxiety and depression, symptoms associated with what we now recognize as seasonal affective disorder.[34]

The same effect occurred wherever cheap manufactured goods encountered indigenous cultures. It happened when colonists brought trade goods and alcohol to Native Americans. It continues to happen today when American tourists wander the globe spreading the glory of our manufactured electronic devices. Native crafts and the teaching relationship between grandparents, parents, and children are pushed

aside and abandoned. From a commodities marketing standpoint in which "the economy" is king, all this might be a good thing. Looking at it from a human culture perspective, or from a mental health perspective, perhaps not so good.

It was based on the recognition that those who make, learn, and grow through the process of making beautiful and useful things thus become the foundation of a moral society and robust economy. Even today, Scandinavian standards of craftsmanship and quality are noted.

In Scandinavia, the Lutheran Church and local governments began programs supporting the use of crafts, recognizing their value and finding importance in carrying on traditions that were no longer tightly held within families. They promoted crafts both in the home and as a major component in education. Educational Sloyd, a system I've written about extensively, was introduced into schools as a means of countering the most destructive modernizing forces in Swedish society.

Just a short aside about Educational Sloyd. The word "sloyd" is an English version of the Swedish word *slöjd*, meaning "skilled" or "handy." In the late 1800s, as manual arts training was being introduced into schools throughout the world, it was one of two competing models. The Russian System aimed to prepare students to take their place in industrial employment, while Sloyd recognized the very close relationship between the use of the hands and the development of intelligence and character. Sloyd proposed that manual arts education not solely develop warm bodies for industrial employment, but also develop a citizenry of higher intelligence, moral standing, and what we might today call "grit." The idea of Sloyd was that participation in crafts offered important values to students because it prepared them to thrive economically and socially in the industrialized world. Lessons in handicrafts shifted from home to the school through Educational Sloyd, which then became a movement in manual arts education even in the United States. Sloyd is a compulsory part of Scandinavian education to this day.

Concerns about the abandonment of traditional crafts and the skills of hand and mind were widely shared throughout the newly industrialized world. The Arts and Crafts movement in the United States was

a response to the sense of dehumanization taking place. The writings of John Ruskin, William Morris, William L. Price, and so many others attempted to move culture in a more wholesome, holistic direction. If the use of the hands is crucial to the development of character and intellect, as they believed, then the importance of engaging the hands in learning is even more critical within families and in schooling. The eminent English scholar and scientist James Crichton-Browne wrote of the importance of hand skills to modern society:

"As the hand centers [parts of the brain involved in sensing and controlling motion] hold a prominent place among the motor centers and are in relation with an organ which in prehension, in touch, and in a thousand different combinations of movement, adds enormously to our intellectual resources, thoughts, and sentiments, it is plain that the highest possible functional activity of these hand centers is of paramount importance not less to mental grasp than to industrial success."[35]

Crichton-Browne went on to note that the development of the hands as a foundation for the development of the mind takes place from ages four to fourteen, after which the hand becomes "relatively fixed and stubborn." This is no less true now than it was in the early days of manual-arts training. Periods of human development that have to do with functions are time sensitive. Psychologist Kathy Sylva elaborates:

"The broader concept of a sensitive period in human development has supplanted the notion of critical periods. A sensitive period may last for months or even years and denotes the time in which the developing child is particularly responsive to certain forms of experience or particularly hindered by their absence."[36]

If we ignore these sensitive periods, we may never fully develop ourselves to our most full capacities. As one example, try learning a new language when you are in your forties (or sixties, as I attempted

with Swedish). You may soon accept the fact that you'll never speak as easily, or with the same fluency, as you would have had you been introduced to a second language as a child. Decide to play the piano in your twenties in the hope of becoming a pro. Good luck, but the odds are against that. Perhaps, with huge effort on your part, you'll overcome the inefficiencies brought on by age. But unless you have truly remarkable gifts, the effort required will be huge. The same applies to other uses of our hands. If we want our hands to function at their highest, they will benefit from early and diverse exercise, and the earlier the better. The preceding may seem a downer to some, but it's intended as an alert for parents and teachers to do what we've always done: assist our children to have fuller, richer lives than our own.

This is not to say that all hope is lost for people beginning a craft in their adulthood. Frank R. Wilson wrote about this subject in *Tone Deaf and All Thumbs? An Invitation to Music-Making for Late Bloomers and Non-Prodigies*. As a physician and as a professor of neurology, he was curious how his young daughter could move her fingers so fast on a piano keyboard, and so he took lessons himself. He found that while we may learn more slowly than the younger set and may not take our piano playing to Carnegie Hall (or, by extension, our crafted objects to the Renwick Gallery), making music can alert our senses, the ear tuned to each note and the fingers savoring their touch to ivory, carrying us all toward greater fulfillment.

In fact, our senses are key not only to making and making well, but also to our enjoyment of the process. Hands on a sanding pad pass over rough wood and feel its transition to smooth. The sounds of the work being done are music to the artisan's ears. The scents arising from the various woods, or even the scent of arriving in the shop where wondrous woods have been sawn, can seize our attention. The senses confirm that what we are doing is meaningful and genuine. Just as an effective novelist will call out and describe the various senses to convince the reader that what's described is actual and worthy of attention, paying attention to our own senses confirms that what we are doing is deeply real, not to be missed or mindlessly avoided.

When I speak of the senses, I have in mind the usual five, including sight, hearing, scent, touch, and taste—all of which may find some use in the woodshop. I admit the sense of taste may be less useful than others in the woodshop, though in some cases what you smell may remind you of something you've tasted in the past. As I mentioned earlier, there's a relationship between how sassafras smells and the taste of root beer.

Sight is of particular importance. For instance, when I apply an oil finish to hardwood, I take delight in the change in color and sheen. Or when I'm planing or jointing wood, my eye travels along the edge to see if I've gotten the wood straight. In shaping wood to a curved form, both the eyes and hands are engaged to see that the form is fair (a term that comes from the boatbuilding craft).

In addition to these five senses, two more are of vital importance in sustaining a high level of engagement in the work. A sixth physical sense involves the muscular sense in the body through which you maintain a sensitivity to the position of each limb and even gain a sense of your relationship to other things, including the Earth itself. The body positioning of Tai Chi comes to mind as I plane wood. The practice has a movement called "warding off," where you hold your feet at a wide stance, one ahead of the other, then spread your legs apart while you push your hands forward, as you would hold a plane as it passes over wood. As you feel your weight shifting from one leg to the other and as your torso follows along in perfect balance, you move with a sense of gravity and purpose that comes through from the Earth. If you're not using hand tools, you can feel the same thing by passing a board across a jointer. And while much of this sensing of the position of each muscle takes place on an unconscious level, bringing that sensation forward and paying greater attention to it enriches the experience and even leads to better health.

This "warding off" movement involves the muscular sense that tells of your own position in relation to the real world. It's a sense that affirms you are really in the world and doing real things. Paying attention to this muscular sense and to your relationship to the Earth's gravitational

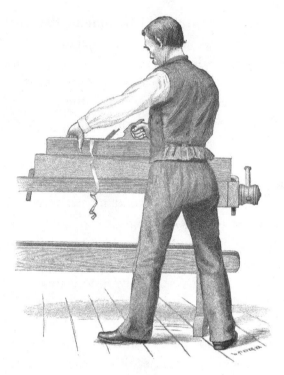

Plate III. Position: Edge-planing.

The planing of wood as shown resembles the Tai Chi
movement called "warding off." From the Sloyd
Teacher Training Academy at Nääs.

force is one of the ways that your life and your work can be made more
deliberate and engaging. Understanding the relationship between your
craft and your state of being can add significant meaning to both.

A seventh sense for engaging with your work is your sense of nar-
rative, as you use all your other senses to interpret the world in which
you exist as "making sense." We often describe a "sense of place" and
a "sense of purpose," both of which fall under the category of mak-
ing sense of our own lives. It is this interpretive narrative sense that
guides craftspeople in their work, for it contains all the other senses
combined into a sense of wholeness about life itself. It is this sense of

wholeness and your understanding of your place within it that drives you forward to learn and create.

I hope brief snippets from my own story—my own way of making sense for myself—lead you to challenge some assumptions you may have made about yourself and others in our society. When I started high school, administrators asked my parents and me whether I intended to go to college. My parents insisted yes, and I was put on a college prep course of studies that kept me out of shop classes that I likely would have enjoyed and that would likely have been of greater use to the life I live now. In their insistence on my attending college, my parents were following a long-held American ideal about education. When he was president of Princeton University, Woodrow Wilson stated that schools would be used to engineer and maintain a two-tiered society:

> "We want one class of persons to have a liberal education, and we want another class of persons, a very much larger class, of necessity, in every society, to forgo the privileges of a liberal education and fit themselves to perform specific difficult manual tasks."[37]

American education still largely follows those lines. We've become a nation fixated on the skills of reading and math. And it's oddly ineffective. More and more we try to get kids reading in kindergarten or, at the very least, by first grade. In Finland children begin reading in school at age eight, and by the time they are measured in Programme for International Student Assessment tests, they far surpass American students in reading. Go figure.

My family had a different understanding of reading readiness. My mother, a kindergarten teacher, had been taught that when a child could skip, they were ready to read, as skipping suggested a level of brain and body maturity. She knew that the development of the hands, eyes, body, and mind were related to each other, but that these aspects of development did not mature in each child at the same time. Part of the role of the teacher, therefore, was to prepare children's bodies (and hands) for learning. I saw renewed interest in this at a Sloyd

Conference at the University of Helsinki, where I found kindergarten teachers learning the basics of woodworking safety and instruction.

So how does this relate to woodworking or to other crafts? Making something depends on a confluence of developmental markers: strength of hand and mind, as well as dexterity in both hand and mind. You must be able to conceptualize a goal, then conceptualize a series of interrelated steps toward that goal and focus attention on each step. There are those who have come to the wrongful conclusion that handwork is mindless. It is not. It offers reason for engagement and a foundation for excitement in learning that the basics of reading and math may not. It also develops the body, preparing it for the efforts of mind in reading, science, and math. Thomas W. Berry wrote in 1912 about the effect of manual work:

> "Not only is the direct influence of manual instruction great but the indirect is even greater. The correlation of studies widens the interest, inculcates the spirit of co-operation and interrelationship, and enables the pupil to express his thoughts not in words only but in models, which necessarily demand precision, thus developing a most useful habit."[38]

Given the walls that education presents between the hands and mind, is it any wonder that many university students are bored and checking Facebook pages while in class and while their bodies are itching to do real things? Sadly, those untrained in the manual arts are left unaware of the benefits of hands-on learning. For them, schooling remains overly abstract and disconnected from real life.

I recognized that I needed to engage learning hands-on and to use whatever real tools I had at hand to support my own child's interest in learning. I observed that my daughter, Lucy, was an amazing source of inspiration for learning to engage creatively. When my daughter was two years old, my wife and I made a craft table and chairs just her size. We modeled the chairs on ones my wife found in a magazine. In our spare time, and while Lucy was asleep, my wife and I painted the

furniture and had great fun working together. Lucy, her mom, and I would sit at that table on the three tiny chairs we had made. Using scissors and play dough, we engaged as a family in craft projects of all kinds. Lucy and I loved making tiny dogs modeled from clay, along with tiny bowls for them to eat and drink from. The table and chairs wait in our attic for when Lucy has children of her own.

When Lucy was about eighteen months old, she began making brief forays into my woodshop, usually in her mother's arms or my own. When she was four, I set up a table where she could build from scraps using glue. She designed and built all kinds of things according to her own interests. I'd scratch my head to understand what they were. "This is a pencil holder," she might say. We have kept a collection of those things in a box in the attic to this day.

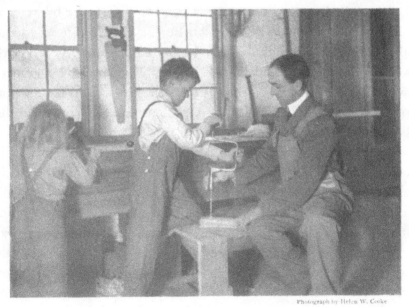

Photograph by Helen W. Cooke

The Shop — the Most Interesting Place in the World on a Stormy Day

From *Carpentry and Woodwork*, by Edwin W. Foster
(Garden City, N.Y.: Doubleday, 1911).

It was working with Lucy in my shop that made me think that more mothers, fathers, and grandparents would enjoy instructing children along similar lines. And that launched me toward becoming a teacher of other people's kids, all the time knowing that their parents were really missing out on something important and particularly grand.

So, while we're waiting for the educational reform that experts acknowledge we need, one that engages the hands to their full potential, do not wait to give that opportunity to your own children and grandchildren. There are so many wonderful ways to engage them in learning about their world, hands-on. You, too, will find joy and inspiration in that.

But say you have no kids and have no intention of having any. Borrow them if you can. There is no better way to energize your own work than to restore a spirit of play in it. As an adult craftsperson, you'll likely be thinking, as most do, about standards of work. Children are much more interested in expressing themselves than in meeting some culturally enforced standard. And restoring the spirit of play will work wonders in your own creative work. My mother counseled her kindergartners' parents that when they asked their children, "What did you do in school today?," the right answer would be, "Play." For play is the essence of learning at its best.

It's also what MIT professor Mitchel Resnick had in mind in his book *Lifelong Kindergarten*, in which he proposed play as the principal means of human expression, learning, and growth. In that book Resnick recalls a visit to the Anne Frank House, where Anne kept her famous diary during the Holocaust. He notes that although she was living in a cramped space and beset with sadness, Anne was constantly experimenting, taking risks, trying new things, testing the boundaries. "In my view," Mitchel wrote, "those are the essential ingredients of play. Play doesn't require open spaces or expensive toys; it requires a combination of curiosity, imagination, and experimentation."[39]

Kindergarten has very important lessons to offer us all in that. Kindergarten was invented by Friedrich Froebel in Germany in

about 1850 and became a new model for learning throughout the world. His original ideas for kindergarten came from observing young German mothers at play with their infants and small children. Froebel noted that learning and growth were as natural to the child as was the growth of a flower. The flower of course was dependent on a few things: air, sunlight, soil, and water. The child, sustained first by mother's love and second by schooling that took the same loving approach, would successfully integrate with life. In his idea of kindergarten, meaning a "garden of children," Froebel observed that learning and growth at their best came through an exploration of the natural and social environment through play. Noting the value of the kindergarten methods, Educational Sloyd used the same principles to build scholastic models for the upper grades. The craftsperson or artisan as well should value this method, finding the spirit of play to animate and energize their work.

Some of the consequences of the introduction of kindergarten in the United States can be measured by its effects. In his autobiography, architect Frank Lloyd Wright recalled the Froebel Blocks he was introduced to as a child, noting, "I can still feel those maple blocks in my hands to this day."[40] Architect Buckminster Fuller developed his first dome-shaped objects in kindergarten. He had such poor eyesight as a child that while the other children were making square-shaped objects from toothpicks and peas (Froebel Gift 19), he discovered the strength of triangular constructions, which evolved into his geodesic domes—and mystified his teachers with his unexpected creativity.

How do we as artisans restore our sense of play with our work? How do we reclaim that spirit of childhood and recognize it is essential to our creativity and growth? The first step is to know how easily that sense of play can go missing from our lives and how fiercely we must defend it.

The question we all, whether amateur or pro, face at one time or another has largely to do with how we keep things fun and infused with the spirit of play. Over the years I've received emails from folks wanting to do what I've done—develop my passion for woodworking

into becoming a professional who makes the bulk of my living from my time in the woodshop. I've always found it difficult to offer a clear formula to them. There are so many factors involved, and there's little that's easy about it. In response to their question, I offer my own questions to them in return.

One involves whether or not their partner is totally supportive. There are very practical matters at hand that involve financial realities. In my own case, I started my professional career while single, living in a one-room basement apartment, and working in the adjoining garage that I had converted to my shop. Living on the cheap gave me an opportunity to learn at a gentle pace and find my way toward some clientele who allowed me to subsist during the early "professionalization" of my craft. Folks who already have family responsibilities may want to check in very carefully and move toward becoming "professional" with some trepidation, making sure of family support.

Another question involves my emailers' ideas of what being a professional might be. Is the term to describe the source of your livelihood, or the quality of your work? One of our most famous American craftspeople, woodworker James Krenov, noted:

> "I'm an amateur and always will be. That's the way I want to die. I'm an amateur by nature and I'm an amateur in fact. And David Pye wrote somewhere that the best work of this century would certainly be done by amateurs."[41]

Amateurs such as Krenov are unfettered by concerns about whether or not they're making enough per hour and are left with the ability to simply do their best. The advantage of being a professional woodworker may be that you get to do a lot more of it. On the other hand, unless you find yourself in very special circumstances—like having the king of Sweden as your early benefactor, as did Krenov—you'll likely have to make certain compromises in order to compete in the marketplace. Being able to avoid those compromises can set the work of the amateur at a higher, loftier plane. The disadvantage is that it's

difficult and demanding (or less than demanding when you've failed to develop a market for your work), and it ceases to be fun when you are overly dependent on it for putting food on the table, paying the mortgage, and helping your daughter through college. It would be a lot more fun if many more folks understood the value of craftsmanship and were willing to support more of it in our communities and pay more for it. But for someone who simply likes to work with their hands, becoming an electrician, carpenter, or plumber is guaranteed to offer more lucrative employment.

I've had the opportunity to teach many woodworkers through classes at art schools and woodworking clubs, and most often they are shy about turning pro, with serious concerns that they will lose all the fun from what they love. It comes as no surprise to me that for many, if not most, doing work for family—children, grandchildren, and spouses—is by far a greater motivating factor than turning pro and doing their work for strangers. And working for family is no deterrent from doing your best work.

Keeping my work fun involves adding variety to it. At this point in my career I've made more inlaid wooden boxes than I can count. I used to keep a rough track of the number of boxes I made by the numbers of thousands of pairs of hinges I'd ordered over the years. I eventually lost track. But making boxes has not been my only work. I keep my energy up by balancing my production of small things with challenging furniture commissions that keep me up at night wondering how I'll successfully resolve whatever challenge became apparent the day before.

For example, in a recent furniture commission that involved making a 42-inch-wide, 8-foot-long table from 2-inch-thick spalted silver maple, it became obvious that the more interesting and beautiful side of the huge, heavy slab (4 feet cut from the original 12-foot slab I used to make a new workbench) had a deep wound where a branch had broken off from the tree. To make the slab useful as a tabletop required filling the wound with epoxy layer by layer, a thing I'd never done before. I inserted stones in the wound for additional interest, creating the effect of pebbles underwater in a brook. By setting up complex challenges like

this for myself, I'm more than ready when one large task is done to take a break and make fifty or a hundred boxes. It's relaxing for me, rather than an oppressive labor. And having stepped back from box making for a time, I look at things afresh with renewed interest and, sometimes, improvements in the efficiency of my work.

When working on a large furniture commission, having promised to make something I've never made, something the customer has never seen except in drawings from our imaginations, and at an agreed price, there's stress involved. Can I really deliver what I promised? Can I do it in the time I estimated? Will I be left with some small profit at the end of it? Box making, where I can answer these questions with a greater degree of certainty because I've made them before, can feel like a vacation from that stress. It delivers the fun of woodworking without the worry about whether or not the customer will be satisfied with what I produce. When working on boxes, I'd look at a pile of them as I was sanding them one by one and count them as though they were already money in the bank, as I knew they would sell and I knew what they'd sell for. I'd feel a sense of comfort in that, even though I didn't know exactly when they'd sell. That may seem mercenary, but we do live in a real world where such things matter. To keep my mercenary thoughts in balance, I'd remind myself of the concept of dual awareness and imagine my own interconnectedness through the objects I was sanding.

One particular thing to note is the importance of launching yourself regularly into the unknown, taking on challenges beyond yourself, and continually testing your abilities in both design and technique. It's little different from your first trip across the monkey bars in preschool. Can I do this? One difference between work and play is that work has an expected outcome. Play welcomes variation and discovery, and it's not just for fun.

Philosopher Jean-Jacques Rousseau described "the great secret of education" as being to "use exercise of mind and body as relaxation one to the other."[42] I can describe how that happens for artisans in woodworking and in other crafts. As I process wood, I use my senses

to fully integrate the experience. I examine wood as it is being sanded, not only to observe defects that will show up later but also to feel with delight its transformation from coarse to smooth. It takes less than a moment of utilizing your hands to keep your mind from succumbing to boredom or disinterest in your work. The senses are key. And using them to your best advantage can turn what might be an odious task into something far more pleasant.

In Frank R. Wilson's *Tone Deaf and All Thumbs?*, he describes four systems of perceptual skills "that can be used alone or together anytime you are playing an instrument."[43] These also apply to craftwork. They are:

1. Visual—you can watch your fingers hit the correct notes;
2. Auditory—you can listen as you play to make sure that the notes follow the patterns you expect to hear;
3. Tactile—you can detect the mechanical contact your fingers, lips, and tongue make with your instrument and make accurate judgments about pressure, temperature, and texture of the surfaces being touched;
4. Kinesthetic—you can feel changes in muscle and joint position as you manipulate the instrument, and use this information to adjust the muscular contractions used to control the instrument.

In addition to these sensory/muscular systems, Wilson adds a fifth system he calls "verbal—a knowledgeable observer who watches and listens can report to you what you did." This is what a teacher does and what critics insist on doing (whether we want them to or not!). Through our own internal dialog, we use what our senses have made known to us and attempt to adjust the work to fit the narrative of our own lives.

It may seem crazy to think that the sounds we make with our tools are worthy of as much attention as sounds we would produce with, say, a clarinet. But the sounds our tools make are important in every

craft. Ask a blacksmith, for example. He can tell from the sound of the hammer striking steel on the anvil when the steel is growing cool and needs to be returned to the forge. In the woodshop, I listen to the plane as it shapes the edge. The whisper provides feedback regarding the quality of the surface it leaves on the wood. With a saw, the frequency of the sound changes as it nears the end of the cut. With a class full of middle school scholars turning wood on the lathe, as I listen to their work I can tell who's struggling and needs my close attention and watchful eyes. When I teach first graders to saw wood, I ask them to listen carefully as they cut.

Hearing and the other senses build the richness of the crafting experience. That richness makes the experience worth attending for decades and longer, just as a beautiful view at the end of a challenging hike over rugged terrain makes it all worthwhile.

Woodworking is a multisensory experience that's more playful and much less painful when all the senses are fully employed. I'm reminded of when I hired a musician friend to help me with a project that involved a lot of sanding. Scott, known for his beautiful vocals, sang in wordless harmony with the random orbital sander and even renamed it "Roy Orbitalsand" in honor of Roy Orbison, the famous musician whose voice modulated in the same high tones. With his sense of humor and attention to both the feel and the sound of the work, Scott helped to craft his day and mine into one in which we felt great joy. It takes less time to enjoy one's work than to succumb to misery and make the task take unbearably longer to perform.

Years ago, a friend suggested that there are two ways of looking at any given task: You *get* to do it, or you *have* to do it. How you choose, "I get to" or "I have to," makes all the difference in the world in how you feel about your work. Nearly all professions, including craftwork, have odious elements that can be approached with a useless frame of mind. Sanding is an example from woodworking. It's dusty. With power tools it's noisy. Sanding can be avoided through the use of a cabinet scraper in some cases. But sanding can be made acceptable if you pay close, playful attention to the effects, both as the work

progresses and in the finished work. I take time to notice and feel the effects of the various grits. The tactile feedback as the work progresses provides a sense of agency and accomplishment. The same satisfaction can be witnessed when you see someone's hand passing with some relish across something you've made and finished well. And so, the line between "get to" and "have to" is like a switch in our attitude separating odious labor from the joy of play.

One advantage that amateur woodworkers have is that they can step away and do the work only when the spirit calls. And yet professionals often get that spirit call when the mortgage is due or an expected check has not shown up in the mail. Being dependent on cash flow from your work is a great motivator to do a lot of it. The Zen saying that poverty is your greatest treasure—never trade it for an easy life—applies. I wonder if I'd be in any way successful without the driving force of poverty to keep me motivated. I've often taken on projects that would not have been my first choice of something to make because a customer had shown up willing to pay and often in the nick of time. So just like every citizen in America living at some point along the line separating the haves from the have-nots, caring for my family came into play in deciding to take the work. But as doing a lot of something offers the chance of getting better at it, poverty and the needs of family have been a driving force in my woodworking.

One of the least fun things for me in my work has been marketing. It is much more fun working in my shop than attending craft shows or making calls on galleries and just hoping that folks will buy enough of my work for me to go home and make more. Both amateurs and pros often ask me how much they should charge for their work, and that's a question I can never settle, as I still have enough challenges of my own in that regard. Attempting to answer that question has a lot to do with what your market is, what your customers are willing to pay, and what level of pay you think is necessary to continue your work. Are you trying to sell your work in a flea market atmosphere, or a well-established and juried craft show where objects of comparable value are sold? If selling in top galleries, you can expect to pocket for

your own expenses less than half of the selling price. If selling in top shows, the expenses are enormous, and your prices should reflect the amount of time you're spending selling your work. And yet the selling price has to be an amount folks are willing to afford. The amateur can avoid all that by simply giving work to charity auctions and to family and friends.

As I've discussed throughout this chapter, family has an important role to play in craftsmanship. To start with, many craftspeople found their start under the watchful eyes and encouragement of parents or grandparents or other family members. In cases like my own, the cooperation, encouragement, and support of family—particularly my daughter and wife—has been of immense value. Making things to meet the needs of their family members is likely the strongest motivation among American amateur woodworkers, beyond their intrinsic need to create.

We understand from our families, hopefully, that learning and play go hand in hand. Pass this along to the next generation through your family and the example you set for others. Whether amateur or pro, keep refreshing your work by doing and learning new things. Start, as a child would start, with your interests. Move from the known to the unknown by doing new things. Challenge yourself to a steady increase in the difficulty of what you do. Move from the simple to the complex, but also learn to simplify as you move forward, touching in both directions. And move from the concrete to the abstract. Exactly what do I mean by that? I will discuss this in another chapter.

COMMUNITY AND THE TRANSCENDENCE OF SELF

"If you want to be followed, you must first serve."

—I CHING

No artisan stands alone in life, as we are, in fact, deeply connected with each other. Have I made that point clear? Even when we are working alone in our shops, other folks creep into our thoughts and into our work. We use materials harvested by others and tools made by others, and we often work to meet the needs of others. As a woodworker in a small town, I'm acutely aware of this. My friends have pieces of my work in their homes, and they were in my thoughts as I created those objects. I may on some days be in their thoughts as well.

No maker of useful beauty is an island unto themself. We read in magazines or books about tools and processes that we are inspired to try. We see things on YouTube that we feel compelled to test for ourselves. We are part of an extended community who asks little of

us except that we test what we've learned in our own shop and then occasionally share the results with others.

As we've discovered in our digital age, community is no longer defined by physical proximity to each other. There are online communities in which we may feel connected, and those communities may soothe our jangled nerves. They may also lead us to action or inspire us to give something of ourselves to various causes, if not in the form of money, at least in the form of our attention, which seems to be the driving force in it all. But there is no real substitute for face-to-face community that evolves over a period of years.

The idea of community need not be narrowly defined to a particular place but is a thing that can grow between artisans as we express interest in each other. For years I was a member of the Arkansas Craft Guild. Even though most of the members saw each other only during shows the guild hosted in Little Rock, we developed feelings over the years as we observed each other's work, watched each other's children grow up, filled in for each other to allow bathroom breaks, and bartered with each other to secure gifts for holiday giving.

Still, there are deeper levels of community that can have a profound impact on the artisan. An old friend of mine told me her story of homesteading with her husband in Gilbert, Arkansas, in the 1940s. In their new home she noticed a few of her treasured things were going missing. She brought the subject up with a neighbor, who explained, "When you move here, what you bring with you is ours, and what you make while you are here is yours." That sounds like a rationalization for theft, but it is also a simple explanation of what it may take to fit into a new community, and here I'm talking about the community that we encounter face to face in our own lives.

Certainly, you can retreat to a walled enclave where a guard lets in only those of your exact kind and keeps out those with whom you choose not to be bothered. That's a luxury most of us do not have, and one that extracts us from the developmental opportunities presented by real life. Do you give yourself to life completely, or are you deliberately holding something back? It's a challenge we all face in

finding our place in life and community, and it's a challenge we may face continuously for years and never outgrow. It's not necessarily easy to plop oneself down in a particular spot and claim all rights of home. Adjustment of self may be required.

When I decided upon a life as a professional craftsman, I was lucky to have chosen a community where I fit and might fit for the long term. I recognize that fitting was not automatic. It required me, to some degree, to adjust my sense of self. Eureka Springs is a small town in the northwest corner of Arkansas, about fifty miles from the Walmart corporate headquarters. It's an odd place with narrow, winding roads passing in and out of town from all directions. It was built around a bunch of springs that were assumed to have healing qualities, and the rugged land made certain that no road would be laid straight. The winding roads give great pleasure to our visitors on motorcycles but are a challenge to other folks traveling in and out of town. Big trucks try to avoid the place. But the quaintness of the town and the scenic beauty of its surrounds make it a place that artists love.

Thanks to the efforts of local artist Louis Freund and others, the whole of the town is on the National Register of Historic Places. It has many miles of stone walls holding up the steep hillsides and Victorian-era homes that require an incredible amount of yearly maintenance. I had never lived in any place like it. My mother noted that with no straight roads within miles of the place, she'd get weary having to turn this way and that. But when you feel a sense of magic in a place, you can put up with a lot. Eureka Springs has been called "where the misfits fit." As someone attempting to become a self-employed craftsman, I knew then as I know now that this place was clearly out of the norm, just as becoming a professional woodworker or an artisan of any kind was outside the norm.

These days, folks move frequently. Many of us have lived in a number of homes in a number of cities or states in a number of communities, as that appears to be the way the economy works. Lacking work or the opportunity to work, we move to find it or more of it. But

I speak here for the value of staying put and building a life within a community. After so many years in Eureka Springs, I can go to the grocery store or the bank or the post office or the library and people know me and welcome my presence. They've come to know me, just as I've come to know them. This is no different from what a friend of mine feels in his small neighborhood in Buffalo, New York. So, it's not a thing found only in small-town America. But "small" means something for sure. Small means seeing and recognizing the same faces over and over and finding value and comfort in each other.

It's not as though I perform an essential service, as does a doctor, a plumber, or a librarian. People, I think, are kind to me just because I try to be nice and attempt to do good work. Participation in a real face-to-face community requires that we find some way to be of direct service to each other: to be handy, at hand, and available to offer whatever skills we've developed or hope to develop.

Getting used to a small town and fitting in there is a lot like learning a craft. You may be first led into a zone of enchantment in which you feel tremendous excitement for everything. Then at some point things can thicken up. I have a very small watercolor painted by a friend. It shows characters wading in mud, and I take it as an excellent illustration of what happens after the glow of a new place begins to wear off and you settle into the routine of things. You can call that the mud zone, where the feet are mired in mud and to move forward requires great resolve.

When my wife and I reached the mud zone in our third year of marriage, we applied as a couple to the United Nations Volunteers. They offered a job for Jean as a librarian in Nairobi, and me a woodworking teaching position on the sinking Pacific island of Tuvalu, neglecting the fact that we wanted to end up together and at the same place. So, we decided to buy a house of our own and have a child instead, which turned out to be for the best. In a way, settling into either a craft or a small town is like distance running. You have to keep running until the endorphins set in. And for us, the endorphins did set in, as I hope they will for you as well.

I can assure you that the high price of fitting in is worth it. Give community all that you can. Just as a ship's first mate calls for all hands, all hands can be the price of admission to community and for all the benefits and challenges being a member of something larger than yourself entails.

Friedrich Froebel's work aimed to bring this sense of community to children, a sense that he struggled to build in his own life. Froebel's mother died while he was an infant. His father remarried, and his young wife showered all her love on young Friedrich until her own first child came along, leaving Friedrich on the outs, fending almost for himself. It was a difficult adjustment, which left him curious about the relationship between mothers and their children and the mother's role in education. Froebel was one of the first educators to recognize and promote the important educational responsibilities of young mothers and, with that, the importance of play.

Before he invented kindergarten in Germany in the 1850s, Froebel wrote two books, one called grandly *Menschenerziehung* (*The Education of Man*) in 1826 and another, *Mutter und Koselieder* (*Mother Play*), in 1844.

Mother Play consists of illustrated songs and verses associated with finger games, with which he intended to bring the child into a better understanding of the human and natural worlds. The games gave the mother overt tools and responsibilities based on what Froebel had observed mothers doing by instinct alone: teaching their children in a playful, holistic manner to become whole within the community and within all of life itself. Part of Froebel's intent was to develop within the child a sense of appreciation for all things.

This appreciation extended even to the very low-class charcoal maker who, in Froebel's time, would have been frighteningly filthy as he came from the forest to sell his wares. To create music, a poem, and finger play associated with the charcoal maker was to make the children aware of his importance in the community: a man not to be feared but appreciated for the essential service he provided. The illustration here shows the hand gesture—much like beginning to

Friedrich Froebel's tribute to the charcoal maker. From *The Songs and Music of Froebel's Mother Play*, by Susan E. Blow (New York: D. Appleton, 1895).

Friedrich Froebel's tribute to the village carpenter. From *The Songs and Music of Froebel's Mother Play*, by Susan E. Blow (New York: D. Appleton, 1895).

hold the hands together to pray—that Froebel used to represent the charcoal maker during the singing of his song.

Another favorite *Mother Play* subject of mine is the *Tischler*, or joiner, a close approximation of who I am today. Please notice in the illustration the small child emulating the *Tischler's* hand gestures as he planes wood. That gesture allowed the child's hands to participate in the singing of the song and the rhythm of the *Tischler's* work.

When Froebel wrote of giving children a sense of community, he used two German terms. The first is *Verbundenheit*, which has been translated as "conscious connection" or "connectedness." What children learned in one subject area should connect them with what they had learned in others, thus building a sense that what they learned and knew in parts was connected to all life. For the artisan, to feel connected to the vast wholeness of all life puts creative resources at your fingertips beyond comprehension. Froebel also used a term, *Gliedganzes*, which he combined from two German words, *Glied*, meaning "member," and *Ganzes*, meaning "whole." His term reflected that while each child was a whole, they were also a member in the

larger wholenesses of family, community, and culture, as well as the natural world.

These terms are useful to consider as you develop in your craft. Your education should be concerned not only with learning important skills, but also with becoming engaged as a creative member of society. What we learn from Froebel is that we all, children and adults alike, learn best through play, and community is the playground that leads us forward in our growth. That is a useful model for every step in life.

Community can be a better teacher than even the most prestigious craft program. Over the years I've met a number of young graduates of such programs eager to show me some of the designs from their sketchbooks, drawings of things they hoped to make. But a sketchbook filled with wonderful ideas is not as direct a path toward the development of the artisan as someone with money willing to invest in your growth. Eureka Springs, even in its early days, was an arts community where a collection of eclectic folks aspired toward some form of creative expression and were willing to invest in others to fulfill their own creative ambitions. I was lucky to have become involved in a community of artists who all had ideas of their own, some of which they were willing to ask me to make.

I'll use my relationship with some friends as an example. Jim Nelson and his wife, Susan, started a leather shop in Eureka Springs in the mid-1970s, selling belts, fine and fancy belt buckles, handbags, wallets, key fobs, and a wide variety of leather goods, some of which they crafted themselves. As their business expanded and their shop moved from one location to another, Jim and I became friends. I sold my inlaid post office boxes through his shop. He began asking me to make various shop fixtures to display products. Each fixture involved new technical and design skills and so led to my growth. In essence, I was being paid to learn. As my own crafting skills grew, the complexity of my work grew also, to the point that I began making furniture for Jim and Susan's home. They were pleased with what I'd made and began promoting my work to their friends and family. They were not rich at the time, but they wanted their own lives and business to reflect

their own creativity and were willing to invest in the life of a friend to make that happen.

The key to my own survival as a craftsman is not related as much to what I wanted to make as to who I wanted to be and how I would find my own place within my community. Despite what some warn, I'll repeat that mixing business with friendship has been essential in this. If you are hoping to fill someone's home with furniture, it is most advantageous for you to be someone they admire and trust, even love. There's a saying that friends will get you through times of no money better than money will get you through times of no friends. I would add that if there's a choice, choose the former. Start on a shoestring, make a few friends, and give it your best shot.

Jim and Susan were not the only people to give me their trust, but I use our relationship as a good example. Jim and I would sit down to lunch in my home, passing napkins between us—him sketching on one and me on the other—as we shared ideas that would then become the next project. Large pieces of furniture for his home and display cabinets for his shop got the same treatment. The napkins serving as our sketchbook would then lead to more detailed drawings, an estimate of costs, a down payment, my crafting of the project, and the delivery of finished work. I always tried to offer Jim and Susan more than was asked for in my designs, giving the work elements of surprise to be discovered while in use. Following the advice of James Krenov, there were no surfaces of the various components that I would consider unimportant to the finished work.

Earlier, I mentioned the narrative quality of work. Just as a novelist tries to edit their work to be compelling and meaningful to readers, the artisan tries to do the same. A craftsperson working in creative collaboration with others offers a rich tale that tells of the relationship between people living in a community. That's a bit more than what you might find in a designer's sketchbook, however aspirational that sketchbook might be. For the finished work offers a more holistic view, as it connects with others and serves to fulfill the expressed needs of real people.

And so, the artisan's first job is not only to do the right work, but also to be the right person doing the right work. The right person is one who is welcomed into others' homes, who is chosen to serve in those homes, and whose growth is furthered by others willing to adopt them.

Knowing the important role that community serves in the growth of the artisan, I'll note that there are some ways to facilitate your engagement. It helps to join a community of peers and become a part of something larger than yourself. You need not join a well-established arts community to find what you need, as you can build community among the friends you seek out. In this, I refer back to Froebel's term *Gliedganzes*, being both a whole individual and a part of a greater whole. Becoming a craftsperson ideally fits one into a holistic relationship with community, whether that's within a physical hometown or within one's community at large.

Other than being the son of a kindergarten teacher, I knew nothing of Froebel at the time I began my own development as an artisan in my adopted hometown. But in retrospect, his teachings make sense. We each seek some form of recognition and a place within the larger wholeness of life. And in order to get what we want, we need to position ourselves to be in service of others.

There's a saying in the *I Ching* that if you want to be followed, you must first serve. By serving others you may compel them to further you in your growth. As I mentioned previously, I used each challenge offered me as an opportunity to learn something new. The exact purpose of the object being made did not matter as much to me as the growth of skills and techniques it provided. Through the exercise of craftsmanship I met my long-term goals.

Let me return to my personal history to suggest how your community can affect your growth as an artisan. By the time I arrived in Eureka Springs in the fall of 1975, it had been discovered by many young folks around my age. Before us, a previous generation of artists and craftspeople had found this place, and like us they had been drawn to the town by its quirky beauty and its natural surrounds. An

Arkansas poet, John Gould Fletcher, wrote to his friends Louis and Elsie Freund, "There's not much happening in Eureka Springs, but it sure is laid out pretty."[44] For my generation, there seemed to be a lot happening, with young folks hugging in the streets and dancing in the parks. It *was* laid out pretty, and it still is.

In the early 1970s hippies began to arrive and formed "the brotherhood co-op" to direct folks into employment as day laborers and as a place for small-scale craft enterprises. I'd come to town to manage the Eureka Pottery Co-op, as its founder was leaving. I was able to take over his basement apartment across the street, where for forty dollars a month I could live cheaply. When the co-op ran out of money and I'd exhausted my small savings, I went to work for Arkansas Primitives, a company making rustic furniture out of old barn boards. Knowing nothing at that time about the expansion and contraction of wood, I'd sweep the snow off boards laid out in the field behind the place, plane them smooth on one side, cut them into parts, and assemble them into china cabinets, hutches, and other country-style designs.

Arkansas Primitives was a loosely managed enterprise. One of us workers would learn how to make something or perform some operation, then teach the next person in line to do what we'd learned to do, and then learn to do the next thing. I didn't know it at the time, but this system followed the "See one, do one, teach one" model of growth that I mentioned before. Arkansas Primitives, in its short life, was a perfect place for me to learn basic woodworking operations. But as a reader of *Fine Woodworking* magazine, I knew there were much higher levels of work to aspire to.

With management being so poor, we workers were left to learn in the ways human beings learn best: move from the known to the unknown, from the easy to the more difficult, from the simple to the complex, and from the concrete to the abstract. The abstract came for me when Arkansas Primitives finally trusted me to design work. I was allowed to imagine, so I just picked up some wood and began to play. Someone surprised me last year by sending me a photo of a glass display case I had designed and signed more than forty years ago, an

early work from Arkansas Primitives.

When Arkansas Primitives went out of business, I drove to Omaha, Nebraska, to pick up the 1948 Shopsmith multipurpose power tool that my dad bought for me used for my fourteenth birthday. With a tool as old as I was and a stop at Sears to buy a few more, I returned to Eureka Springs to start my life as a "professional" woodworker in the ramshackle garage attached to my forty-dollar-a-month basement apartment. I lived there on the cheap for six years as I attempted to build a career as a woodworker.

Becoming a part of my community required me, as a budding artisan, to stick my neck out. In 1977, there was some talk in the local paper about Eureka Springs needing an art guild. In response to that, I made a few calls, dropped in on a few artists I knew, and called for a meeting of artists and craftspeople at Lake Leatherwood, a city-owned park north of town. About twenty artists and craftspeople showed up, and, in addition to acquiring a severe case of chiggers from sitting in the grass at lakeside, I was elected president because I was the only one who came with a notebook to record attendance and contact information and make a list of possible members. Over the next few weeks, the Eureka Springs Guild of Artists and Craftspeople formalized with thirty members. Among the projects it took on was an arts and crafts show that became an annual event. The organization survived in our small local community until the late 1990s. We disbanded it then so that we might turn our attention to establishing a school.

It seemed obvious and inevitable that a small city with as many artists and craftspeople as Eureka Springs would have an art guild. It became equally obvious after a few years that our next step would be to form a school. So, in 1998 we opened the Eureka Springs School of the Arts. In 2020 it received a ten-million-dollar endowment to secure its operations for decades to come. The endowment came from a foundation run by friends I'd begun making furniture for in 1994. The foundation of those same friends has sponsored my Wisdom of the Hands program at the Clear Spring School since 2001.

If I could point to any single factor as responsible for my continued

success as a craftsman, I would point to friends. And I believe that their support of my work is due to my commitment to both my community and my craftsmanship, as well as my having concerns beyond economic success.

I once heard a guru say that most people think that the spiritual path is impractical, but that it is in fact most practical—that by being of service to others we may also be of service to ourselves. We become, in a cyclical manner, of greater usefulness to others. What is your spiritual path? Can it be one in which you attempt to be of service to others? As simple as that? Can you strive for both security and growth at the same time?

What is the role of the artisan in the vast scheme of things? As makers, you make culture. As makers, you make community. As makers, you make meaning and you make life more meaningful for others. If you have doubts, try crafting for yourself.

I was particularly lucky to have found my way to Eureka Springs and to have been embraced as a member of an arts community. I would not be who I am or do what I do without having been given some shape by my community. I know for certain that the path of community that I found in Eureka Springs can be duplicated in other places, each unique. Gather friends; encourage them in their work. Be sincere in your aspirations and flexible in response to what your community asks of you. Humility will be useful at every point in your career.

There is, of course, an alternative to seeking community in your work. You could identify yourself as a separate person and dwell on that isolated sense of self, failing to fully grasp your own interconnectedness with others. You could identify yourself as being from a separate class of folks, and wall yourself off from others except those of your own accepted kind. You could, if you aspire to it, focus your time and attention toward the accrual of wealth, which then allows you to retreat behind walls. You could accumulate stuff, which then isolates you from finding and having greater meaning.

But consider that the self is never really alone, nor are there distinct boundaries between us. I recall that when I lived in Memphis as

a young adult, I would sit in Shelby Forest north of town and watch the Mississippi River flow by so silently that I could hear voices of fishermen a mile away on the other side. I think too of negative space in art, space that is captured between objects and shapes. Negative space is not empty space. It's like the river of my earlier days, not empty but filled with both water and the sound of voices from the other side. There are thoughts there. There are relationships, noticed and unnoticed. You can choose to focus on the separate shapes (one of which you self-identify and defend as yourself), or you can focus upon the relationships that form the interconnectedness between all things.

So, here's a simple suggestion (perhaps more like a hammer striking steel): Those who self-identify within the narrow confines of their own bodies and their own stuff to the exclusion of all else have very good reasons to fear death, as it's likely their end of being. Those who direct their love and trust toward all others will stand in the light of eternal life. My conclusion may not have anything to do with the afterlife consolations offered by religions. It may not even be true in the very long term of things. But if you are one who attempts to make things that are useful and beautiful and meaningful as well, perhaps my conclusion offers some hope. Or maybe it's the best I can hope for. Whether anything I've made will last centuries or even decades is for others to decide.

CHAPTER 9

CRAFTING HUMAN CULTURE

"The most powerful drive in the ascent of man is his pleasure in his own skill.... You see it in the magnificence with which he carves and builds, the loving care, the gaiety, the effrontery. The monuments are supposed to commemorate kings and religions, heroes, dogmas, but in the end the man they commemorate is the builder."

—JACOB BRONOWSKI

There are several avenues open to those who want to take part in crafting human culture. One is to make beautiful and useful things that enrich the lives of others. Another is to teach, be it literature, dance, music, or some other form of art. To share the gifts of culture through teaching is profound. A third way is to write, which is in itself a form of teaching. A fourth way is to live authentically in the real world. Your example will serve others.

My own contributions as maker, teacher, writer, and activist were influenced by the era in which I started as a craftsperson. When we hippies moved to Arkansas in the 1970s, from all over the United States, most of us were leaving things behind that were not much to our liking. One was the military-industrial complex that sent young

men and women to unnecessary war. Another was the devaluation of labor that had taken place in the American economy and culture. Another was the estrangement of the consumer from the sources of supply. Another was the cost of participating in an economy that lacked sensitivity to the environment.

Many of us felt that the then-current course of things, which has nevertheless persisted to this day, was and is unsustainable. Society at large (we felt) was in a state of moral decline. Those of us who were artisans or felt compelled to become artisans felt like we were saving a few things from being lost: hard-earned lessons about materials, tools, techniques, and the creative human spirit. We were not just making stuff; we were saving techniques and ways of life, learning how to be closer to the land, more respectful of the environment, and more humane. Just as the characters in Ray Bradbury's *Fahrenheit 451* were saving books by walking around in constant recitation, we were building and saving skills that had been useful throughout the rise of humankind. If things really went to hell in a handbasket, as some of us suspected they might, the skills we were mastering would be useful, not only to ourselves and each other for crafting our own lives, but also to those we might teach in putting society back together.

How to raise vegetables, goats, and chickens on poor soil and rocky hillsides is not a bad thing to know if the world is falling apart. Knowing how to make a clay pot and how to cut and dry firewood for the winter offer not only means to make a living, but also preparation for a future when these skills might be needed. How do you make something useful from wood you have harvested from your own small acreage? My community in Eureka Springs knew that even if things did not fall apart, we were learning and growing in our skills as well as in kindness and character as we encouraged each other.

Does this sound silly today? Perhaps I'd better go charge my cell phone so I can check the weather to see if it's raining outside. But we were influenced by the ancient hills on which we were living. There was evidence of earlier life in the form of arrowheads and other stone

tools left by people who are now gone. In my front yard there are dry stacked stone remains of a spring house where an earlier settler had kept their meager produce from the harsh landscape. Those were people who lived lightly on the Earth and left little physical evidence to show for it, while we, members of current civilization, leave huge scars even if we attempt to live more lightly than most. One of my wintertime chores of late has been to remove old wire fencing that at one time kept hogs from wandering too far from the pioneer homestead. I take the wire to the recycling center to be used in the making of new steel, but that's a very small drop in the bucket compared with what the garbage trucks haul off each week.

My community aspired to live lightly on the land and work that land ourselves. Two of the most popular magazines of those hippie days were *Foxfire* magazine, which told how to do simple things the old way, and *Whole Earth Catalog*, which offered practical information for a new age. Another favorite was *Mother Earth News*, from which I got my first writer's paycheck for fifty bucks for an article I submitted about peeing on sawdust (an excellent way to recycle a by-product from my work). We were a group of folks trying to avoid what Bob Dylan called in "It's Alright, Ma" being "bent out of shape from society's pliers," preferring that we'd use pliers of our own making if anything needed to be bent.

In addition to woodworking, I became involved in a local movement to save our springs from being polluted by the town's ancient and failing sewage collection and treatment system. With a group of young folks, I was one of the founders of an organization we called the National Water Center. We chose such a pretentious name knowing what we faced locally was truly national in scope. And we celebrated and proposed a National Water Week to attempt to attract the larger public to our cause. I became the chairman of the Citizen's Advisory Committee on Water and Sewer for the Eureka Springs City Council to help oversee and make recommendations as we attempted to clean up our springs, which had once been considered healing, and reduce the volume of dirty water unleashed downstream.

That was my first step into a role as an environmentalist, a role that later reached its high point when we stopped a major electric power corporation from forcing unnecessary high-voltage power lines through our county. I was vice president of Save The Ozarks, a single-issue organization that took on this fight. My role was to mobilize the folks throughout a two-county area by writing editorials proving that the power lines were not needed and not wanted. I wrote that they would destroy the scenic beauty that artists depend on for our work and that drew so many tourists to fund the town's tourist-based economy. I regard that exercise of citizen power as one of the culminations of my life, but also a demonstration of how community-wide citizen action can effect change. That we were a community of artists with a shared passion for the beauty of our place helped cement our resolve.

Was that attack by a power company the gloom and doom on the horizon that we expected, and for which we honed our skills as artisans to confront? No. But our reaction to it became a display of the power that citizens can wield when they are able to speak and act passionately together for an important cause.

Another cause that we rallied around was teaching. Back in the late 1940s, Louis and Elsie Freund founded the Summer Art School of the Ozarks in Eureka Springs. It was a small thing, a hobby school with only a few students, but it gave some of us ideas for our own venture. In about 1994, the Year of American Crafts, local painter and sculptor Mary Springer and I decided to turn the Guild of Artists and Craftspeople, which I'd helped found in 1978, into a not-for-profit organization to begin teaching classes. We began to work on the Eureka Springs School of the Arts (ESSA), starting as a school without walls, which meant that we held classes in the studios of various artists in town. ESSA is now more than twenty years old and is a complex of a dozen buildings on more than fifty acres of land. It serves hundreds of students from all over the United States each year. Its endowment ensures that it will continue to serve far beyond the extent of my own life. The mission of the school is to bring greater

meaning to our residents and guests, to raise the stature of the arts in our community and region, and to make lasting contributions to our human culture. It is, of course, a direct outgrowth of our artists community and our efforts to emphasize the arts in Eureka Springs.

The Freunds played another important role in leading the direction of our community. In the 1960s, Louis began lobbying the Eureka Springs City Council and the Eureka Springs Chamber of Commerce to form a historic district for the preservation of our Victorian architecture. He argued that while folks spent millions of dollars to re-create Colonial Williamsburg, all our city needed to do was preserve and protect the unique character of what we already had, a town filled with architecture from a bygone era. The Eureka Springs Historic District was established in 1970, and our city has served as an example to other Midwestern cities seeking to preserve their historic places.

Writing is both a direct contribution to human culture and an opportunity to exchange more than crafting technique. In about 1994, I began writing articles for various woodworking magazines, and in 1997 I published my first woodworking how-to book, *Creating Beautiful Boxes with Inlay Techniques*. When I was contacted by Popular Woodworking Books about doing the book for them, I told the senior editor that I didn't want to write a "how-to book," but was interested in writing a "why-to book." The compromise the editor offered was this: if I would provide sixteen box-making projects, complete with step-by-step instructions and photographs of each step, I could add a sidebar on philosophy to each chapter. The formula worked. The book sold well, and I wondered what to do next, as we must always leverage success toward greater service.

I'll return for a moment to teaching, which I found to be an essential service to my community. In 2001, I became engaged in conversations on the internet with folks concerned that woodworking was no longer being taught in schools. My daughter, Lucy, was attending a small private grade school in Eureka Springs, and it was planning to add a new high school. I asked the head of the school if he planned

to have woodworking as a part of the new school, and he said that he would if I could find funding to support it. For some time leading up to that date, I had observed the role my own hands play in my life and in my craft, and the importance the hands offer to every other field of human endeavor. The value of hands-on learning was widely proclaimed but rarely utilized. I proposed a truly hands-on wood-working class at the Clear Spring School. American Poet Laureate Stanley Kunitz's poem "Wisdom of the Body" gave me the title for the program, Wisdom of the Hands. The program is now in its twentieth year. It is not meant to make woodworkers of our kids, and it is meant not only to give them proficiency in tool use, but also to do what Educational Sloyd was first proposed to do: to raise students' general levels of intelligence and character.

I've been lucky enough to have started a few enterprises that have helped others. Louis Freund called me a visionary. I think it might have been his way of saying I was impractical. Part of the job of a visionary is to look beyond what's practical to what needs to be done, and then to step out of the way for others more capable to carry a plan forth. We seek to do those things that we recognize as inevitable and make them our own. For example, it seemed absurd to me that Eureka Springs did not have an art guild when I arrived in town. Others, recognizing the same absurdity, stepped forward to craft what I could not do alone but that we all knew needed to be done. The same was true of the Eureka Springs School of the Arts. And the same was true for the Wisdom of the Hands program.

Hands gained newfound respect during the recent COVID-19 crisis. The hands of doctors and nurses helped to save us, along with the hands of grocery clerks, mail carriers, UPS drivers, and the scientific community. But technology has brought us to the point of screaming—just as we did while riding our bikes and letting go of the handlebars and yelling "Look, ma, no hands"—as we hurtle toward a future that's unknown to us. That's not so good. What happens when a generation of children raised on 3D printing visit a museum? Will they have an adequate grasp of what they see? Will they comprehend what hands

and minds were able to do without the technology upon which they depend? Will they be lured to attempt to replicate what they see? Will they realize that behind each brushstroke on a piece painted by a great master was a well-practiced real human hand? Will they understand what Geoffrey Chaucer meant when he said, "The lyf so short, the craft so long to lerne, the' assay so hard, so sharp the conqueryinge"?

I think the virtual world and the virtuous one can be worlds apart. While I have memories of my father teaching me how to use a hammer, today's child will have memories of their dad teaching them stratagems for their Game Boy or Xbox. These are not new concerns. We've faced them with every new age. John Ruskin warned us about the loss of the human soul to the machine, the time when culture would become soulless and empty of both empathy and meaning. Does the number of channels we are able to stream or the skill of narrowing the breadth and scope of our writing to fit Twitter standards measure up to past advances in human culture?

Woodworking philosopher David Pye wrestled with the question: In the age of machines, how do we find value in handcrafted work? Here he describes one answer, what he calls "workmanship of risk":

"If I must ascribe a meaning to the word craftsmanship, I shall say as a first approximation that it means simply workmanship using any kind of technique or apparatus, in which the quality of the result is not predetermined, but depends on the judgement, dexterity and care which the maker exercises as he works. The essential idea is that the quality of the result is continually at risk during the process of making; and so, I shall call this kind of workmanship 'the workmanship of risk.'... It may be mentioned in passing that in workmanship the care counts for more than the judgement and dexterity; though care may well become habitual and unconscious."[45]

The real value of the handcrafted is that when you embark on doing things you've never done, and you face risk of failure in doing so, you have an opportunity for individual personal growth. Automated

machine production cannot allow this except to those persons who designed and set up the machines for others to use.

When it comes to the culture you inhabit and enjoy, you have the choice of whether you craft it for yourself, and thereby contribute something of yourself to the culture enjoyed by others, or you let it be delivered to you by parties unknown while failing to put forward your own creativity and originality. You identify more fully with those who have shown creative power and with the things they make when you've developed creative powers of your own. And here I'm not talking about ordering folks around to do the ugly work to honor your ugliest of selves. You can use your phones for that. I'm talking about the humble person who invests in learning skills that they might use to benefit others. Martin Luther insisted that each human be taught a trade, not just one of the mind, but of the whole body, that human culture might be woven of whole cloth. In the Jewish faith the Talmud warns:

"As it is your duty to teach your son the law, teach him a trade. Disobedience to this ordinance exposes one to just contempt, for thereby the social conditions of all are endangered.... He who does not have his son taught a trade prepares him to be a robber.... He who applies himself to study alone is like him who has no God."

David Pye emphasizes the idea of "care." Would you rather live in a world in which people care, or would you live in a world where folks care only about money or what money can buy and fail thereby to recognize your own creative powers? Finnish brain researcher Matti Bergström warned:

"The brain discovers what the fingers explore.... If we don't use our fingers, if in childhood we become 'finger blind,' the rich network of nerves is impoverished—which represents a huge loss to the brain and thwarts the individual's all-round development. Those who shaped our age-old traditions always understood this. But today Western civilization, an information-obsessed society that

overvalues science and undervalues true worth, has forgotten it all. We are value-damaged."[46]

We cannot say, as we watch a child's fingers flashing around on their handheld digital device, that their fingers are not engaged. They can move those at a frenzied pace. But what about the full range of sensing and creative capacity that the hands offer? And what does Matti mean by the term "value-damaged"? Are there important things we learn about the world by being engaged hands-on, things we will not learn from our iPhones, our fingers sliding smoothly on glass?

What Matti was warning about is a narrowing of the range of perceived values to the point that the monetary worth of the object is all that matters. We see that in our richer classes. In that crowd of folks, the only reason to value a Vincent van Gogh painting is that you can sell it to some collector or another for forty million smackers, or because owning it makes you appear rich, granting the bragging points treasured in that realm. Such folks do not value the momentous shift van Gogh brought to the world of art, feel the need to celebrate his life and his gifts, or find rapture from his inspiration. If you learn to look at life only through the lens that money provides, how will you value wilderness or mother's love, or any form of art to its full depth? And how will you learn to bask in and celebrate those diverse things that give greater meaning to life?

Either we are active participants in the creation of human culture, or we are passive consumers of it. Those who make things—whether lovely, handcrafted things from wood, or music, or spaghetti—have a leg up on, or should I say a stronger grasp than, those who allow themselves to become idle consumers of a culture produced by others.

What are some steps for engaging in cultural renewal?

1. Make things that give you an understanding of the labors of others and labor's value.
2. Encourage others, particularly your own children, to make things.

3. Return crafts, music, and the arts to the forefront in American education.
4. Grasp the idea that your brains are in your hands, and allow that to give shape to what comes next.
5. Invest not in things but in others.
6. Pay particular attention to that which is real, to that which you can do with your own hands, and apply yourself in that direction.

I have serious concerns about how things are now, and I suspect you may too. Folks come to this small town where I live not because it's cheap, but because it's lovely. They make art not because they make money doing it, but because it fulfills values that are far deeper than that. And so, we can talk about the economy and we can talk about human culture. Yes, they are intertwined. But culture is so much more, and it takes very little money to craft it. Even a woodworker in Arkansas can take a whack at it.

CHAPTER 10

LEFT HAND, RIGHT HAND

"Two hands clap and there is a sound. What is the sound of one hand?"

—HAKUIN EKAKU

There's a famous Zen koan about a master who asked a young monk, "What is the sound of one hand clapping?" The acolyte went hither and yon, returning with what he thought might be the right answer. "Is it the sound of a bell?" he asked. No, it was not a bell, so the young monk went out again into the world. "Is it the sound of water running in the brook?" he asked when he returned. Again and again, he went out and came back with proposed answers to the simple question. What is the right answer? Could it be right before your nose, as you take one hand and clap and listen directly for yourself?

As someone who's spent most of his life working with his hands, I suggest that they work best in partnership. To actually clap, both hands must meet somewhere in the middle. As an experiment, take a piece of paper and try writing on it, and observe how your opposing hand steadies the paper.

We live in a world that's deeply divided, with one faction being named "left" and the other "right."

For hundreds of years those whose left hands were dominant were described as evil.[47] We learned the serious error in that. Today, we live in a world that's deeply divided across a political line described as left and right. I have a hypothesis that the hands actually have the potential of bringing us together, just as one hand assists the work of the other. Just like the young monk, running all over to discover the sound of one hand clapping, we've been left distrusting what's right before our noses and unprepared to accept the obvious. Charles H. Ham wrote in his book *Mind and Hand*:

> "It is easy to juggle with words, to argue in a circle, to make the worse appear the better reason, and to reach false conclusions which wear a plausible aspect. But it is not so with things. If the cylinder is not tight, the steam engine is a lifeless mass of iron of no value whatever. A flaw in the wheel of the locomotive wrecks the train. Through a defective flue in the chimney the house is set on fire. A lie in the concrete is always hideous; like murder, it will out. Hence it is that the mind is liable to fall into grave errors until it is fortified by the wise counsel of the practical hand."[48]

While the mind seeks the truth, the hands together—left and right—most often find it. When we leave the hands out of the search for truth, we base our sense of reality on beliefs proposed by others. In that lies the blame for a fragmented society. Were we all engaged in artisanship of some sort, the things we and others made would reveal truths to us, and we would have a fundamental understanding of each other as well as a firm grasp of that which is real. We would find better ways to be of service to each other.

We can clearly grasp the ways that the exercise of craftsmanship, a path toward refining our labor to make useful beauty, is a moral exercise. But how does craftsmanship affect the intelligence of humans? Historian Jacob Bronowski described the hand as the "cutting edge of the mind." He also noted:

"The discoveries of science, the works of art are explorations—more, are explosions, of a hidden likeness. The discoverer or the artist presents in them two aspects of nature and fuses them into one. This is the act of creation, in which an original thought is born, and it is the same act in original science and original art."[49]

So, how are the arts and sciences similar, and how does one breed and foment the other? They arise from the same basic curiosity about life. The left brain is strongly associated with science, as it plods its way through reason and experimentation and documentation of results. The right brain is associated with flights of imagination and fancy.

Yet the walls between the arts, crafts, and sciences are paper thin. All require the development of critical thinking and the cultivated power of close observation. Earlier I mentioned my potter friend who became fascinated by formulating glazes and returned to school to train as a chemical engineer. As a potter, he specialized in making and selling cup and bowl sets, for those, to him, met the essential needs of humanity, his clientele.

You can't whittle a stick (holding the knife in one hand and the stick in the other) without making simple unspoken hypotheses about the impact of the grain and the angle of the knife's edge applied to the wood. Neither the knife nor the wood lie about the results. What is intelligence without the practice of observation and critique? And what is intelligence if it does not allow you to better manage real life?

There is another Zen story that I've found meaningful. A Zen master was dying and his disciples were gathered around him, pleading, "Master, please don't leave us!" He asked in return, "Where do you think I'd go?"

When you are at rest with the world, left and and right hands bringing you to center and in relationship to all things, perhaps you've found truth. The hands are instruments through which our creative imaginations are brought to bear in transforming the material world. They are also sensing devices that confirm our reality and measure our sacred place within it.

We live these days in a world in which folks think it's OK to make stuff up. Folks get to believe what they want, and if they can get others infected with their beliefs, they think they've found truth. I call BS. There is a real world, and we live in it whether it pleases us or not.

CHAPTER 11

FORGIVENESS

"To err is human; to forgive, divine."

—ALEXANDER POPE, *An Essay on Criticism*

An essential attribute for most craftspeople, including me, is an attitude of self-forgiveness, which may come into play each and every day in the workshop. One hazard of being human is that by trying new things we inevitably make mistakes. But are they mistakes? Or are they gifts?

Today I was doing a bit of home remodeling, making a white oak panel to cover an access hole in my guest bedroom. It's not your glamour job by any means, but it will be an improvement that will allow for attaching a small wall-mounted bedside table. When you're dealing with power tools, things can go out of alignment. When you're dealing with a human mind that's likely to be forgetful or distracted, things can get even worse. So, a loose router bit climbed out of the collet and cut too deep, forcing me to adjust my plan. The outcome of my misadventure, fortunately, is much more to my liking than it would have been following plan A, before the error was made.

Like most woodworkers, I've learned the importance of plan B, sometimes C, D, and E. Sometimes when plans B, C, D, and E don't seem reasonable, I start over. I find that a fresh start often goes quickly,

as I've already practiced the wrong way and so am clearer and more confident in my mind as to how to get things right.

To engage in self-recrimination is a waste of time. Anger feeds self-recrimination and feelings of self-doubt and leaves you unwilling to risk further work until it passes. Perfection is elusive and perhaps a less worthy goal than forgiveness. And when you realize forgiveness, you can then extend it as empathy to others as well.

I am reminded of a young man who came through town a number of years ago looking for a place to drop anchor with his small family. He was a refugee of sorts from the prestigious College of the Redwoods, having found the tutelage of James Krenov not at all to his liking. He was in the process of shifting from cabinetmaking to woodturning in the hopes it might be more satisfying and less demanding of perfection. He had accepted that it's OK to screw up, and with that knowledge he found it was not so difficult to bear occasional criticism.

I used to attend conferences of the Furniture Society, a national organization dedicated to studio furniture. In one of its popular evening events, called Slide Wars, furniture makers showed slides of their work on a large screen to a large, raucous audience. It was a time in the evening at which most attendees had been drinking, and I admired those willing to display pictures of their work, knowing how rude the audience could be as they called out insults to various artisans' work. Most casual observers would miss the backstory behind each piece, the tools used, the obstacles surmounted, and, to put it in Jerome S. Bruner's vocabulary, the narrative that the slides only partially revealed. The venue was much too large for one-on-one conversations or the thoughtfulness that might entail. The audience response lacked the kindness that can be essential to those who aspire to do good work. Missing also was the empathy essential to begin to understand the presenter's work.

It is a bit easier to achieve perfection in work if you are allowed to creep up on it using hand tools instead of power tools. Turn a router on and things can quickly go downhill. But of course the speed at which you can get work over and done with makes using machines

enticing, providing everything goes just right.

The legend of John Henry is a classic tale of human versus machine. The most likely truth behind the legend is this: John was a Black man and was hired out from a Kentucky prison in the 1870s to dig a railroad tunnel through solid rock. He swung a ten-pound hammer against a steel rod, drilling into the rock face so that dynamite could be placed in the hole. During his era, steam drills were being introduced, taking over the difficult and demanding task that exposed workers to deadly rock dust and dehumanizing toil. A competition was set up between John and the steam drill. John won but lost his life in the effort.

We would be wrong to assume that the competition was purely a muscle versus motor encounter, discounting, as is most often done, the intelligence behind each hammer strike. Nearly forgotten in the legend was the shaker man, whose job was to shake and turn the steel bit between hammer blows to clear the rock dust from the hole. Without the work of the shaker man, the drill bit would have come to a complete halt, just as debris must be cleared when chiseling a mortise or drilling deeply into wood. And yet, John is the hero of the tale and is very likely buried in a ditch behind the prison where he (if he were alive) could hear the whistle of passing trains—the results of his work.

In our machine age we've become intolerant of signs of the human touch. For example, when we go to the grocery store, if a cardboard container shows signs of damage, we'll dig to grab one from behind, even though the box is destined for the trash when we get home. I try to make each of my inlaid boxes as perfect as I am able, to make certain that none are left on the shelf due to some small imperfection that would lead a customer to choose not to buy my work or for the gallery to choose not to reorder what I make. I always try to make each box unique, a job made easier by the process I use to make the inlay strips. Also, to make things easier for galleries to reorder, I standardize a range of sizes, each size at a set price.

There is absolutely nothing wrong with the pursuit of perfection

in your work, unless it devalues your sense of self and diminishes your ability to exercise forgiveness. Japanese craftspeople, as well as Amish artisans in our own country, believe that their task is not to attain absolute perfection but to simply strive for it, as it is unattainable and perhaps even undesirable. An Amish quilter would leave one stitch undone, rather than compete directly with the divine. I can't imagine doing that intentionally. But I make mistakes. Only rarely have I completed a project without some unintentional thing having happened in the making of it. Even when everything goes just as planned, I ideally learn something in the process that would make a second attempt better. And that applies even to boxes, of which I've made thousands.

Woodworking is an invitation to the simple matter of human forgiveness. Wood continues to move as it ages, and the woodworker must not only make an object, but also anticipate where it will go in the course of its life and the changes in circumstance and moisture conditions it will face. And so the craftspeople in wood strive for quality work as well as quality in their capacity to forgive materials, circumstances, and self.

Most of us who live as artisans have a particular experience that may challenge our ability to self-forgive. My own episode involves a bed, two chests of drawers, and matching side tables commissioned by my aunt and uncle. They wanted my work in their home, but no doubt also wanted to encourage my growth as a woodworker. I assembled the bed, side tables, and carcasses for the chests of drawers using wedged mortise and tenon joints, and I made all the drawers with hand-cut dovetails. Upon completion, I rented a U-Haul trailer to deliver the furniture to Pittsburgh, Pennsylvania. Unobserved by me, there were rivets sticking up from the floor of the trailer, and by the time I reached Pittsburgh, they had scarred the wood on one of the chests of drawers. I was heartbroken. I was devastated. My aunt and uncle were kind and loving, as one would expect. They took me to a hardware store for supplies to repair the damage, and I did my best to make things right. And yet, what I had hoped to deliver as perfect has haunted me ever since.

Craftspeople naturally strive to get better at their work, hoping to show themselves as being of quality and worthy of admiration or love. Those who commission craftspeople's work may be motivated by love and respect, and they may bring this to the work even before the first piece of wood is cut, stitch is sewn, or clay is wedged. The craftspeople may disappoint themselves, and yet it is necessary that they move on, learn from the lessons life offers, and continue to serve, buoyed by an understanding that love at its best is unconditional and must be received and passed on. And what's an artisan to do in the face of such love? Carry on in the hopes of assisting others.

Woodturners have a useful way of moving beyond the mistakes they make, calling them "design opportunities." I've had many of those myself, errors that have led to fresh designs and the development of new techniques. So I've learned not to get angry when I err, but to reflect.

By proposing forgiveness I'm not suggesting that work be sloppily or lazily done. Some have a tendency to account for poor-quality work by claiming it to be handmade and therefore to be excused at a lower standard. We artisans are, to some degree, competing against the perfection of machine-made goods. Growth and industriousness in what we do is an essential element in healthy humanity. Keep striving for greater perfection. But keep forgiveness comfortably at hand. You'll need it.

CHAPTER 12

TO RECLAIM
WHAT IS REAL

"Give the pupils something to do, not something to learn;
and the doing is of such a nature as to demand thinking;
learning naturally results."

—JOHN DEWEY

Earlier I suggested that craftspeople would benefit from moving from the concrete to the abstract, and here I'll explore that in slightly greater depth. In the early part of the nineteenth century, the educator Johann Heinrich Pestalozzi met with a teacher in his small school in Switzerland. The teacher was using pictures to illustrate various words, and the word "ladder" came up. A student challenged his teacher, asking, "You're trying to teach us the word 'ladder,' but instead of looking at a picture, wouldn't it be better if we went out and looked at the real one in the shed?" The teacher was frustrated by the interruption and kept his students indoors. Later, the word "window" came up and the student interrupted again, asking, "Why are we looking at a picture when there's a real window right there, and we don't even have to go outside to look at it?" When the teacher complained, Pestalozzi informed him that the student was right. Kids

are best taught by instruction in and from the real world.

It is said that educator Otto Salomon kept a stone he picked up at Pestalozzi's grave site on his desk. I have a stone from Salomon's on mine. The stone is a solid representation of the concrete and its importance in learning. I could have simply taken a picture of the grave (which I did) as a visual reference, but the stone has weight and texture, engaging a deeper connection with my senses. And, of course, our own senses are deeply connected to the power of the concrete to engage learning and the energies we harvest from making beautiful and useful things.

We learn best from real life, and we have the ability to discern the difference between that which is real and that which has been contrived by others for our learning. Real life interests and engages us. Other material, when we know it's fabricated for our instruction, quickly becomes boring, and we become disinterested and likely to opt out.

But how does this relationship between the concrete and abstract play out in the life of a craftsperson or artisan? Going back to the first chapters of this book concerning materials, tools, techniques, and design, I'll present an example from each.

Materials have actual weight and dimension, and there's an inter-relationship between parts that is difficult to express in an abstract form regardless of how diligently you work to draw the various details. Even the characteristics of the materials and the tools you use have their effect. For example, you might think veneered plywood would be a very simple material and therefore easy to cut. Using very sharp carbide blades gives the modern craftsperson an advantage in this. But in practice, the downward force of the blade can cause the veneer to chip out rather than cut clean on the underside of the wood. So, while you might expect good or even great results, concrete experience informs otherwise. You could use a more expensive saw with a scoring blade that cuts from both sides of the wood to prevent that tear-out. Not having that saw, I've put masking tape down on the underside of the plywood where the cut is to be made. The tape helps to hold

the individual wood fibers in place and lessens the downward tearing force of the blade. Another option is to use a tight-fitting, zero-clearance insert in the table saw that provides greater backing to resist the downward force of the blade. Planning is one thing, experience another, and experience is a territory that is derived from the concrete, then enlivens and solidifies the realm of abstraction.

The same lesson applies to other materials used in woodworking. In working with hardwoods, as I mentioned before, the grain matters. There's nothing abstract about it, and close observation of wood grain and cutting or planing with a concrete understanding can make a profound difference in the finished work. Experience of the concrete is exactly the same in other crafts as well. This is the reason many schools of architecture have students design and make furniture. Working on built projects gives the students a good grasp of the design process. It demonstrates how deep they must go in thinking through and describing a design in complete detail in order for it to be fully understood.

The tools used in crafts are the expression of many generations of human development. Each embodies knowledge both in its making and in the specifics of its use. While tools exist as concrete forms, the knowledge of how they are useful and used may be abstract until you see them in use. They become even less abstract when you take them into your own hands, feel their weight, apply them to the material, and sense their effects in your whole body firsthand.

Techniques also tend to exist in the realm of abstraction until you take them in hand and test their effects. I could talk about carving, inlay, hinge installation, or the use of story sticks for easy measurement. I could describe details, making these things only slightly less abstract. An example is a tool that I've named a "flipping story stick." It relies on things being symmetrical, left and right. In routing mortises for hinges to fit a box, I take a thin strip of wood and cut a slot in it that's exactly sized so that the hinge fits. This stick, being the exact same length as the back of the box, is then used to set up stops along the router table fence that allow the hinge mortise to be routed exactly on one side. When that's complete, I flip the story stick end

over end and use the same opening to set up a second position for the router table stops. Of course when I describe this, the technique will be quite abstract except for those readers to whom I've already taught the technique through the use of photographs in books and articles, and even less abstract for those who've tried it for themselves. When you try techniques using the tools and materials at hand, making certain of their effects, you've made them concrete. If you are concerned about making things that last, take into consideration the nature of the materials and techniques used to connect the various elements into form.

Design, too, is best executed with a concrete understanding of materials' characteristics, weights, strengths, and working qualities, as well as how they will actually perform in use. Design must also take into consideration the tools and techniques that are to be used. I use sketches to go from idea to proposed design. Use of models further solidifies the design process. Even practice in cutting a single joint in full size can help in the process of moving from the concrete to the abstract. More recently I've used computer-based drafting programs that allow you to rotate the object you're planning and to view it from various angles. You can also add it to room settings to show where it will fit. But the 3D design programs remove the need for the designer to work at an even deeper level where prior experience had been gained.

The abstract is an alluring force. When I first moved to Eureka Springs, we hippies congregated at a coffee shop for strong coffee and veggie hash browns rich in onions, potatoes, and cheese. All of us folks coming from rented apartments or in from the land had aspirations rooted in the abstract. Some wanted to be writers, though they had not as yet published a word. Others were musicians or carpenters or involved in one craft or another, but all of us had been drawn together by abstract ideas and ideals about ourselves and the lives we hoped to build. We knew and accepted each other on the pronouncements of what we were to become, regardless of what we were at the time.

I recall fondly those abstract conceptions from our early days in

Eureka Springs. But the concrete also comes into play as you design your own life. Are you to be mired forever in the abstractions of self—what you might become some day at some time when external conditions become just right? Or do you grasp the immediacy of the concrete and go to work in the real world? Can you take your own hands, left and right, and clap them together before your own eyes, thus putting the Zen master's question to rest? The world of the concrete is where you make things happen, whether it's a simple box, a spoon, or a manuscript reflecting on the process through which you craft your own life. The materials, tools, techniques, and design you employ to make useful beauty can propel your life forward, step by step, just as certainly as your hope of what you might become.

CRAFTING USEFUL BEAUTY

"I want to be able to work a piece of wood into an object that contributes something beautiful and useful to everyday life."

—SAM MALOOF

"Craft" is both a noun and a verb. It represents both objects made by humans and the active making of those objects. I may craft something, and that something will be called craft. It is odd that we don't use "art" in the same way. Something I've made might be called art, but I would never art it into its existence, though I might craft it into being what it is. We would never spend our time arting, without having to reengineer how we speak and feeling foolish in the attempt.

Most woodworkers in my experience are reluctant to think of themselves as artists, as we tend to be concerned with practical things, and practicality is not often associated with art. But there are some inherent problems in distinguishing art from craft. As a woodworker involved over the years with various "art" and "craft" enterprises, forgive me if I just plunge right in. Even last week I participated in a related discussion with board members of the Eureka Springs School

of the Arts. Some tried to differentiate between "fine crafts" and "crafting," which they described as little more than gluing googly eyes and feathers on pecan shells. I think it is simply healthier to disregard the distinctions between "fine crafts" and "crafting" and between "art" and "craft" and trust people to grow on their own. We do not all start out at the same level in our work or with the same circumstances, and with some encouragement there are no limits to our potential growth. It is far more useful to encourage each other than to sit in judgment of one another's work, particularly over the distinction of whether something is "art" or "craft."

A basket by Arkansas artist Leon Niehues.

That being said, we still want those words to stand for something. Many years ago a jeweler came to a meeting of the Eureka Springs Guild of Artists and Craftspeople. Bragging about how effective he was at selling, he made the dubious statement, "If you can sell it, it's

art." One of the guild members asked him if that applied to toilet paper, which sold well each day at our local supermarket.

A number of years back, as Walmart heiress Alice Walton was building Crystal Bridges Museum of American Art, she was collecting paintings by many of the great American masters. I met her at a craft show where I was selling my work and asked if she planned to acquire any furniture by eighteenth-century American maker John Townsend. It was not such a strange question. A few years earlier, internationally known art critic Robert Hughes had proclaimed Townsend's work as the very pinnacle of achievement in American art. But most people have a deeply ingrained view that art goes on walls or is never to be touched, and practical things designed to be used and touched are not "art."

While Ms. Walton did not respond directly to my question, the museum has mounted major exhibitions exploring the dubious boundary between art and craft. The common perception of difference between art and craft is that craft tends to be more strongly focused on making useful objects or on making objects that have traditionally offered use. That idea is changing. For example, my friend Leon Niehues's basketmaking is a traditional craft, but no one would see his work as anything but art. His basketry shows his unique vision of what was once a commonplace humble and useful craft. It provides evidence of skill and craftsmanship of the highest degree. But if you were to try to find usefulness in it other than to be lovely and worthy of admiration, to serve as a decorative force, or to evidence the sophistication of its collector (and this is not a criticism of Leon's work), try your luck. Providing inspiration to others is useful and necessary from a cultural and artistic standpoint, and Leon's basketry serves that use as well.

We worship art as expressions of the artists' souls and as reflections of our own souls. But then we turn around and inhabit our lives with soulless objects fed to us by machines, made in distant lands, transported to us over the seas, and distributed through big-box stores. The environmental costs of manufacturing and transportation are enormous, but they are far exceeded by the costs of missed opportunity

to our own communities, economy, culture, and intellect by our not making the things we need on our own.

I visualize a new world in which objects like Leon's basketry—common things of useful beauty—inhabit our homes and lives. I use the word "useful" because to be of some use to others is a driving principle for many craftspeople. In this new world we, like Wharton Esherick, mentioned in the next chapter, might find value not just with groundbreaking, norm-shattering art, but with crafts that may have come from others in our own communities.

A spoon might serve as an example. At Clear Spring School we did an exercise shaping and steam bending thin pieces of white oak to form common kitchen utensils. Each utensil could be regarded as both a sculptural object and something useful in the kitchen, as though it had no other purpose than to stir batter or flip pancakes. When worn out, they could be composted and replaced with utensils made from new wood.

Another example might be wooden postcards from lovely Arkansas veneers that I've been making in my shop. They are not meant to be sent through the mail but to be stamped, postmarked, and given to friends. They are sculptural forms, laminated in a vacuum press over forms crafted from solid wood. They are designed to convey a message that can be either thrown away or kept. Are they art or craft? They may be a little of each, and it probably doesn't matter.

I want to speak briefly of the value of simple things. In major ports throughout the world there are freeports, duty-free storage facilities where great art is safely stored and bought and sold without ever seeing the light of day and without being shared. That great art has been turned into a commodity. Simple things, crafts, are no less lovingly made than great art, but are made to be used up and composted when the value of their message has been sufficiently understood and shared, one person to another.

I suggest that you make things caringly, even when you know they are not to be kept. Make things with the idea that they may last for generations. How long they will last is decidedly in the hands of the person who receives the objects you create. Will they be cared for? Or

will they go into the trash? It is interesting that some things delicately made last and are kept and cared for, while some things of more robust construction hit the landfill in record time. The deciding factors in this may just be the feelings that you convey through the making, sharing, and use of your labor. Once work leaves your hands, its ultimate destination is determined by others.

An anthropologist visiting the island of Bali asked local people about their art. After attempting to explain what art is (a difficult subject even for anthropologists), he was told, "We have no art. We do *everything* as well as we can." And in that I find the starting point of a path forward. As I mentioned, I live in a town largely dedicated to the arts. We have more professional artists than we have bankers, doctors, lawyers, and other professionals combined. Even some of our doctors are artists, and they practice at an inspiring level in both careers. But if people continue to value only those artworks that hang on walls, sit on pedestals, or are packed away in storage vaults, where do my neighbors and I fit in? Where do you as a craftsperson fit in?

Recognizing the wisdom of your hands calls for an awakening to your own personal need to create useful beauty. Make things not for tomorrow, to be admired, displayed on shelves or on walls, and not touched. Make things for today, for the joy of making them, the joy of sharing them, and the joy of using them up as they enrich your own life and build connections with others. Can we redirect our efforts toward making things that express the twin concepts of being both useful and beautiful and therefore meaningful as well?

You need not be a great artist to take part in cultural renewal. A friend of mine, Dan, and his wife, Susan, live in the neighboring town of Berryville. Susan noticed among her friends a demand for small tables and decided that making them would be a great way for Dan to keep busy in his retirement years. Dan's assignment: make them cheap and affordable from whatever materials he could scrounge up. They need not be perfect. In fact, a high level of craftsmanship would interfere with Susan's ability to keep the inventory moving and the tables selling fast and at a low price that her customers could afford.

Dan enjoys finding materials for his tables that would otherwise be thrown away. To keep his own life interesting and his woodworking enthusiasm up, he began taking classes in a local woodshop. It's a formula that works. Dan works on things that bring growth to his craft and other things that offer quick sales and fulfill a need.

Dan's formula is a bit like mine. I've spent years ironing out the bugs on making boxes, while making more challenging one-of-a-kind pieces keeps my creative juices flowing. Many craftspeople seem to make similar arrangements. One of my woodworking students was a ninety-six-year-old professor of engineering, an internationally known specialist in naval propulsion, and a woodworker on the side. Another was the assistant district attorney in Los Angeles County. Woodworking students come from all walks of life. The avocational aspects of crafts can provide respite from other endeavors and renew the energy you have available for all else.

And when I observe one of my students working on a lathe, it's not just the formation of the perfect shape that comes to my mind, but the student's crafting of self. Let all things grow from there.

CHAPTER 14

CRAFTING A
PATH FORWARD

"Some of us long to have at least something, somewhere, which will give us harmony and a sense of durability—I won't say permanence, but durability—things that, through the years, become more and more beautiful, things we can leave to our children."

—JAMES KRENOV

There's a thing that happens as you develop skill and expertise in a craft. When you are just starting out, few people beyond your immediate family may be interested in your work. As your work develops to be more in keeping with the accepted standards in the society in which you live, you can establish a wider market if you have a mind to go in that direction. At some point, your work and its qualities may grow beyond folks' willingness to pay full value for what you've invested in it. That's why James Krenov recognized the value of the amateur's work, done not for money—because money won't likely pay what it's truly worth—but for love of the work.

There is often an inverse relationship between the advances in the qualities you invest in your craft and the size of the market for it. We artisans are inwardly compelled to get better at our work. In

some cases, as in John Henry's tale, faster and faster may suffice along with pain, suffering, glory, and death. Those who must be paid fairly for their work must compete for attention and dollars from a small number of the wealthiest clientele. What a different thing it might be if common folk understood the true value of their local craftspeople's contributions and were willing to invest in them to reach their best.

I know some people like that. Around twenty years ago, I was visiting some friends for whom I'd made a series of cabinets for their collection of American crafts. At the same time, they had visitors from four museums to which they were gifting works from their collection. It was an amazing experience for me to listen to the curators talk about the various works and how they might fit in not only to their collections but also as valuable contributions to the culture at large. The vantage points of a maker of things and of a curator of things can be a bit apart. My friends were inviting the curators to take what they wanted for free, which was remarkable to me. My friends are generous like that. They wanted the artisans whose works they loved to receive recognition for their accomplishments from museums. And making some space in the cabinetry I'd built for them would allow them to purchase new work, thus giving further support and encouragement to the artisans they loved.

I tell this story because it is important for folks to know that there are people like that—people who deserve our emulation, setting the best possible model for the culture at large. Just imagine a world in which we *all* reach to understand the true worth and value of an artisan's work, a world in which we reshape our economy and our expectations of ourselves to support such work.

A few years back, my high school students in woodshop were noticing that most of the things in their households had come from China. I asked, "Do you have anything in your house that was made by someone you know?" One of my students answered, "I have that bowl I turned in woodshop." I knew the one he was talking about and why he mentioned it, as it was a particularly lovely thing. My students live in a community of artists and craftspeople, so surely there were more things in their homes than that one bowl.

Turned maple bowl by Ike Doss.

I have in mind Wharton Esherick, who was called the "Dean of American Craftsmen" for the role he played in the Studio Crafts movement. It's said that in the home that he designed and built himself, now preserved as the Wharton Esherick Museum, there are no objects that he did not make or that were not made by someone he knew and cared for. So, when I say it's time for things to change, that's exactly what I have in mind—that we fill our lives with things of useful beauty that are made by people we care for and that represent their growth as craftspeople. We have an economy dedicated to the exchange of dollars, rather than one dedicated to promoting people's character and intelligence by supporting their work.

We recognize the power of crafts and artisanship and unique talents and interests to shape and mold the integrity of the individual. Did we make a societal mistake when we became so reliant on machines and international trade to provide us with the common things we need? Did we allow ourselves to be distracted by the

promises of cheap stuff instead of using our need for things to build the communities in which we live? When we acquire cheap stuff, we create a system in which useful things are expendable and quickly abandoned in our haste to acquire new, meaningless stuff.

Architect William L. Price, founder of the Rose Valley art colony in suburban Philadelphia, called for a change to consumer culture in 1909:

> "Not so many things, but better, must be the cry of the consumer, and things good enough to be a joy in the making must be the demand of the worker, and until these demands become peremptory we shall hope in vain for a civilization that shall be worth while."[50]

It's very hard for you as a craftsperson to compete with the flood of cheap stuff if you're thinking only of dollars and cents and discounting the growth of your intelligence and character that takes place when you make things of useful beauty. It is not surprising that people who chose to support my work have themselves been engaged in some manner in the arts, which gave them insight into what the creation of beauty means to the development of the individual. It appears to work that way.

It was at one time more widely understood that we each share a responsibility in crafting the communities in which we live. How do we craft communities? It may be enough for you to simply craft yourself as an artisan getting better each day at what you do. But it is rare for artisans to reach their highest potential without the encouragement of others. That suggests you make connections, perhaps as a teacher in some fashion or another. Even going out into the world to show your work, explain it, and sell it is a form of instruction.

We need the arts of all kinds to dominate in the halls of education at all levels, for both children and adults. The arts and applied sciences move learning from the grip of academic abstraction toward real life and a high level of student engagement, prekindergarten through university training and beyond. Art must be integrated with our homes and communities as well, and our hands must take their proper place

in guiding our future. We need a framework in which we perceive our own value not in what we own, but in the growth we have enabled in each other.

Human beings throughout hundreds of thousands of years of evolution have been dependent on accurate observations of their natural environment for survival. While we think of science being newly derived, accuracy of scientific observation is not. Knowing where food could be found, knowing how and when to take shelter from dangerous circumstances, and knowing how to make the objects necessary for subsistence and safety were crucial factors that no single individual could ignore. Today, we can live in the shelter of our homes and offices, surrounded by objects manufactured by others, without a thought to the weather outside, and without regard for the external consequences of the choices we make in living our lives.

These circumstances allow us to live completely out of harmony with the natural environment without ever knowing that we do so, and without ever anticipating that we or future generations of our kind will pay a price for it. We might feel far superior to the men and women who walked the Earth hundreds or thousands of years ago, but they lived in harmony with the natural environment in a sustained symbiotic relationship dependent on acute attention and skilled observation. At this point, in comparison, we live thoughtlessly, with our minds caught up in internal dialog, which we escape only to enter the unreal worlds of computer screens and television.

You don't need an expert to tell you the truth of this. You can know it from careful observation of your own life.

In the early age of science, British admiral Sir Francis Beaufort developed a scale with which any common seaman could take useful measurements of wind velocity based on directly observable phenomena. Through the use of the Beaufort scale, the British Admiralty gathered an incredible amount of data enabling safer navigation of British ships throughout the world. The Beaufort wind scale was an example of a framework for scientific investigation that gave the common seaman an important role in scientific investigation. It illustrated that even the

common man (or woman) might have a role in science and that direct observations made by individuals can be of value. For those not at sea, there is a land version that allows an observer to note the wind velocity based on the movement of leaves, branches, and trees, or simple things like the way the smoke rises from a chimney. The wisdom of our hands is an invitation for academics to move beyond the purity of intellectual academic pursuits and for the tradesmen, craftspeople, and common men and women of the world to move beyond the motions of the purely mechanical toward a renewed primacy of direct observation, and recognition of the value of one's own direct perceptions.

The interesting thing about the Beaufort scale is that it presents a model of how we might measure our own growth, and the growth of our children and the effectiveness of our schooling. It is simple. Just as the Beaufort scale was simple enough that the common British seaman could make accurate scientific observations, a simple scale would allow us each to measure necessary change, no PhD in education required.

The National Endowment for the Arts was interested in measuring its own effect outside the realm of standardized testing, and while it's difficult to place measurable joy or happiness on an exact 100-point numerical scale, there are things that can be observed that put measurable joy into a simple framework. For instance, does your child like going to school? Is your child anxious to get there and less anxious to come home? Does your child have fun things to share when they arrive home that reveal to you that the experience is joyful for them?

In our own lives as craftspeople, we can easily monitor our growth by setting goals for ourselves and noting the joy we feel in reaching those goals. It can be the same for children, schools, and communities. Instead of focusing on abstract standardized test scores as our measure of school success, or economic statistics as a measure for our communities, can we measure joy instead? Can simple goals be set for the growth of joy in our communities?

The Beaufort scale is indeed a very simple thing. With the land version, when you look at a tree and all the leaves are perfectly still,

the scale marks zero. When the leaves flutter very slightly, the scale is at one. It goes up to ten for a hurricane-force wind. We need a fresh breeze to blow in American education, and for us to witness greater joy in our own lives and in the lives of those around us would be the best measure of that success. Along the same lines is the following suggestion by David Henry Feldman:

> "I submit that the twin signs of progress toward a fruitful education for the future are; (1) an increasing number of individuals engaged and committed to pursuit of mastery of their fields and (2) the number of novel, unprecedented, or unique contributions that occur in these fields."

He's referring to craftsmanship. The engagement of the hands holds the key for that. Let's accept the fact that where the hands are engaged, the heart and mind likely follow.

There is a profound shift when we change from consumers to makers. There is a similar shift when we engage others to make for us the useful beauty we hope might inhabit and enrich our own lives. Even the most simple and basic objects can provide a pathway toward growth, either for ourselves or for others. To awaken growth in others is a profound gift that works both ways. Not only does it feel good to be a part of someone else's growth, but it also builds within culture a continuity, a compounding of further gifts and growth.

You need not be a benefactor with enormous wealth to bring about needed change. You can start very simple and very small. Attend your farmers market to see what others are doing, making, and growing. Attend craft shows and allow yourself to be inspired. Establish an island of competence, however small, and let your own growth proceed toward new continents. Among friends, we launch a revolution.

Let's build relationships in our own communities to encourage artists and craftspeople to create. Let's take a chance on art and practical crafts to provide what we need, and let's watch artists and craftspeople grow. This will lead to an alternative economy in time, populating our

lives with things that other people we know and care for have made. We will feel richer for it. This will lead to happier, healthier families and communities, less fear of others, and the crafting of greater equity in a world that appears at times to have been torn apart.

For those just starting out as artisans, you may not as yet see yourselves as part of a revolution. You may just want to get better at your work without any larger picture in mind. Craftsmanship is like that. The urge to get good at something is universal when unimpeded. And that urge is followed by another restless urge to get better at what you've just done. Start with what interests you. Move gradually from the known to the unknown, from the easy to the more difficult, from the simple to the complex, and from the concrete to the abstract. As your hands become skilled in their tasks, let your mind grasp your place in the larger scheme of things.

NOTES

1. Charles Bell, *The Hand: Its Mechanism and Vital Endowments as Evincing Design* (Philadelphia: Carey, Lea & Blanchard, 1833).
2. Charles A. Bennett offers the following as the source of the quote: "A lieu de coller un enfant sur des livres, si je l'occupe dans un atelier, ses mains travaillent au profit de son esprit: il devient philosophe et croit n'être qu'un ouvrier."—Jean-Jacques Rousseau, *Oeurres Completes, Tome III* (Paris: Dalibon, Libraire, 1824), 348.
3. John Perlin, *A Forest Journey: The Role of Wood in the Development of Civilization* (Cambridge, MA: Harvard University Press, 1989).
4. See "Spalted Wood," accessed April 30, 2021, http://spaltedwood.com.
5. Richard Louv, *Last Child in the Woods: Saving Our Children from Nature-Deficit Disorder* (Chapel Hill, NC: Algonquin Books, 2005).
6. Ivan Illich, *Tools for Conviviality* (New York: Marion Boyars, 1973).
7. Rudolfs J. Drillis, "Folk Norms and Biomechanics," *Human Factors* 5, no. 5 (1963): 427–41.
8. Charles H. Ham, *Mind and Hand: Manual Training, the Chief Factor in Education* (New York: Harper & Brothers, 1886).
9. Illich, *Tools for Conviviality*.
10. L. Jäncke, N. J. Shah, and M. Peters, "Cortical Activations in Primary and Secondary Motor Areas for Complex Bimanual Movements in Professional Pianists," *Brain Research. Cognitive Brain Research* 10, nos. 1–2 (September 2000): 177–83. DOI: 10.1016/s0926-6410(00)00028-8. PMID: 10978706.
11. Michael Polanyi, *The Tacit Dimension* (Chicago: University of Chicago Press, 2013).
12. Matthew B. Crawford, *The World beyond Your Head: How to Flourish in an Age of Distraction* (New York: Macmillan, 2016).
13. Zhuangzi, *The Dexterous Butcher*. Lord Wen-hui said, "That's good, indeed! Ting the cook has shown me how to find the Way to nurture life." Chuang Tzu, the inner chapters.
14. Ellis A. Davidson, *The Amateur House Carpenter: A Guide in Building, Making, and Repairing* (London: Chapman & Hall, 1875).
15. Ham, *Mind and Hand*.

16. John Dewey and Evelyn Dewey, *Schools of To-morrow* (New York: E. P. Dutton, 1915).

17. Geoffrey Chaucer, "Parliament of Fowls," prologue (https://www.poetspress.org/Chaucer-Parliament.html).

18. Unless otherwise cited, biographical information included in this book has been sourced from Wikipedia.

19. William L. Hunter, comp., "Two Hundred Poems for Teachers of Industrial Arts Education" (unpublished manuscript, 1933).

20. David Pye, *The Nature and Art of Workmanship* (New York: Van Nostrand Reinhold, 1968).

21. Jerome S. Bruner, *On Knowing: Essays for the Left Hand* (Cambridge, MA: Belknap Press of Harvard University Press, 1962).

22. "Research Programs," NeURoscience Lambert Lab, accessed April 30, 2021, https://www.kellylambertlab.com/research.

23. "Goldin-Meadow Laboratory," accessed April 30, 2021, https://voices.uchicago.edu/goldinmeadowlab/.

24. Frank R. Wilson, *The Hand: How Its Use Shapes the Brain, Language, and Human Culture* (New York: Vintage Books, 1998).

25. Otto Salomon, *The Theory of Educational Sloyd: The Only Authorized Edition of the Lectures of Otto Salomon* (London: George Philip and Son, 1892).

26. See "Jonathan Baldwin Turner," https://en.wikipedia.org/wiki/Jonathan_Baldwin_Turner.

27. "A classical teacher who has no original, spontaneous power of thought, and knows nothing but Latin and Greek, however perfectly, is enough to stultify a whole generation of boys and make them all pedantic fools like himself. The idea of infusing mind, or creating or even materially increasing it, by the daily inculcation of unintelligible words—all this awful wringing to get blood out of a turnip—will, at any rate, never succeed except in the hands of the eminently wise and prudent, who have had long experience in the process; the plain, blunt sense of the unsophisticated will never realize cost in the operation. There are, moreover, probably, few men who do not already talk more, in proportion to what they really know, than they ought to. This chronic diarrhea of exhortation, which the social atmosphere of the age tends to engender, tends far less to public health than many suppose." —Jonathan Baldwin Turner's Griggsville Address, 1850.

28. David Henry Feldman, "The Child as Craftsman," *Phi Delta Kappan* 58, no. 1 (September 1976): 143–49.

29. Matti Bergström, *The Brain's Resources: A Book about the Origin of Ideas* (Jönköping, Sweden: Seminarium Förlag, 1990).

30. Robert Brooks and Sam Goldstein, *Raising Resilient Children: Fostering Strength, Hope, and Optimism in Your Child* (New York: McGraw-Hill, 2002).

31. Howard Gruber, "Afterword," in David Henry Feldman, *Beyond Universals in Cognitive Development* (Norwood, NJ: Ablex, 1980).

32. Bergström, *The Brain's Resources*, 147–48.

33. John Amos Comenius, *The Orbis Pictus of John Amos Comenius*, https://books. google.com/books/about/The_Orbis_Pictus_of_John_Amos_Comenius.html?id= oQRBAAAAIAAJ.

34. Charles A. Bennett, *History of Manual and Industrial Education, 1870–1917* (Peoria, IL: Manual Arts Press, 1937), 55.

35. James Crichton-Browne, in Gustaf Larsson, *Sloyd* (Boston: Principal Sloyd Training School, 1902).

36. Kathy Sylva, "Critical Periods in Childhood Learning," *British Medical Bulletin* 53 (1997).

37. Woodrow Wilson, "The Meaning of a Liberal Education," address given to the New York City High School Teacher's Association, 1909.

38. Thomas W. Berry, *The Pedagogy of Educational Handicraft* (London: Blackie, 1912).

39. Mitchel Resnick, *Lifelong Kindergarten: Cultivating Creativity through Projects, Passion, Peers, and Play* (Cambridge, MA: MIT Press, 2017).

40. Frank Lloyd Wright, *An Autobiography* (New York: Longmans, Green, 1932).

41. An interview of James Krenov conducted August 12–13, 2004, by Oscar Fitzgerald for the Archives of American Art's Nanette L. Laitman Documentation Project.

42. Jean-Jacques Rousseau, *Emile; Or Education,* trans. Barbara Foxley (London: J. M. Dent and Sons, 1921; New York: E. P. Dutton, 1921).

43. Frank R. Wilson, *Tone Deaf and All Thumbs? An Invitation to Music-Making for Late Bloomers and Non-Prodigies* (New York: Viking Penguin, 1986).

44. Personal correspondence between Fletcher and Louis Freund conveyed directly to the author.

45. Pye, *Nature and Art.*

46. Patricia Livingston and David Mitchell, *Will-Developed Intelligence: Handwork & Practical Arts in the Waldorf School* (Fair Oaks, CA: Association of Waldorf Schools of North America, 1999), 11. See also www.waldorflibrary.org/journals/15-gateways/428-fallwinter-2001-issue-41-supporting-the-development-of-the-hand.

47. Ethel J. Alpenfels wrote about the culture preference for the right hand in 1955: "The cultural world in which man lives, both in preliterate and in technologically advanced societies, tends to be a 'right-handed' world…. The right and left hand have come to symbolize good as opposed to evil, gods as opposed to demons. Hence, they are considered as two forces constantly at war with one another." Ethel J. Alpenfels, "The Anthropology and Social Significance of the Human Hand," *Artificial Limbs* 2, no. 2 (May 1955): 4–21.

48. Ham, *Mind and Hand.*

49. Jacob Bronowski, *Science and Human Values* (New York: J. Messner, 1956), 30. See also Jacob Bronowski, *The Ascent of Man* (Boston: Little, Brown, 1974).

50. William L. Price, "The Beautiful City," *The Craftsman* 17, no. 1 (October 1909): 57.

FURTHER READING

Selective Bibliography

Bell, Charles. *The Hand: Its Mechanism and Vital Endowments as Evincing Design.* Philadelphia: Carey, Lea & Blanchard, 1833.

Bennett, Charles A. *History of Manual and Industrial Education up to 1870.* Peoria, IL: Manual Arts Press, 1926.

Bennett, Charles A. *History of Manual and Industrial Education, 1870–1917.* Peoria, IL: Manual Arts Press, 1937.

Berensohn, Paulus. *Finding One's Way with Clay: Pinched Pottery and the Color of Clay.* New York: Simon and Schuster, 1972.

Bergström, Matti. *The Brain's Resources: A Book about the Origin of Ideas.* Jönköping, Sweden: Seminarium Förlag, 1990.

Bronowski, Jacob. *Science and Human Values.* New York: J. Messner, 1956. See also Bronowski, Jacob. *The Ascent of Man.* Boston: Little, Brown, 1974.

Brooks, Robert, and Sam Goldstein. *Raising Resilient Children: Fostering Strength, Hope, and Optimism in Your Child.* New York: McGraw-Hill, 2002.

Bruner, Jerome S. *On Knowing: Essays for the Left Hand.* Cambridge, MA: Belknap Press of Harvard University Press, 1962.

Comenius, John Amos. *Didactica magna* [The great didactic]. 1657.

Crawford, Matthew B. *The World Beyond Your Head: How to Flourish in an Age of Distraction.* New York: Macmillan, 2016.

Davidson, Ellis A. *The Amateur House Carpenter: A Guide in Building, Making, and Repairing.* London: Chapman & Hall, 1875.

Dewey, John, and Evelyn Dewey. *Schools of To-morrow.* New York: E. P. Dutton, 1915.

Ham, Charles H. *Mind and Hand: Manual Training, the Chief Factor in Education.* New York: Harper & Brothers, 1886.

Hunter, William L., comp. *"Two Hundred Poems for Teachers of Industrial Arts Education."* Unpublished manuscript, 1933.

Illich, Ivan. *Tools for Conviviality.* New York: Marion Boyars, 1973.

Larsson, Gustaf. *Sloyd.* Boston: Principal Sloyd Training School, 1902.

Livingston, Patricia, and David Mitchell. *Will-Developed Intelligence: Handwork & Practical Arts in the Waldorf School.* Fair Oaks, CA: Association of Waldorf Schools of North America, 1999.

Louv, Richard. *Last Child in the Woods: Saving Our Children from Nature-Deficit Disorder.* Chapel Hill, NC: Algonquin Books, 2005.

Polanyi, Michael. *The Tacit Dimension.* Chicago: University of Chicago Press, 2013.

Pye, David. *The Nature and Aesthetics of Design.* New York: Van Nostrand Reinhold, 1978.

Pye, David. *The Nature and Art of Workmanship.* New York: Van Nostrand Reinhold, 1968.

Resnick, Mitchel. *Lifelong Kindergarten: Cultivating Creativity through Projects, Passion, Peers, and Play.* Cambridge, MA: MIT Press, 2017.

Salomon, Otto. *The Teacher's Hand-Book of Slöjd.* Boston: Silver, Burdett, 1904.

Salomon, Otto. *The Theory of Educational Sloyd.* London: George Philip and Son, 1892.

Wilson, Frank R. *The Hand: How Its Use Shapes the Brain, Language, and Human Culture.* New York: Vintage Books, 1998.

Educational Resources

On Kindergarten

Blow, Susan E. *Songs and Music of Froebel's Mother Play*. New York: D. Appleton, 1895.

Bowen, H. Courthope. *Froebel and Education through Self-Activity*. New York: Charles Scribner's Sons, 1897.

Brosterman, Norman. *Inventing Kindergarten*. New York: Henry N. Abrams, 1997.

Stowe, Doug. *Making Classic Toys That Teach: Step-by-Step Instructions for Building Froebel's Iconic Developmental Toys*. Nashville, TN: Spring House Press, 2016.

Wiebé, Edward. *The Paradise of Childhood*. Springfield, MA: Milton Bradley, 1896.

On Sloyd

Hoffman, B. B. *The Sloyd System of Woodworking*. New York: American Book Company, 1892.

Larsson, Gustaf. *Elementary Sloyd and Whittling*. New York: Silver, Burdett, 1906.

Larsson, Gustaf. *Sloyd*. Boston: Principal Sloyd Training School, 1902.

Rich, Ednah Anne. *Paper Sloyd for Primary Grades*. Boston: Ginn, 1905.

Suttcliffe, John D. *Hand-Craft*. London: Griffith, Farren, Okeden & Welsh, 1890.

Whittaker, David J. *The International Impact and Legacy of Educational Sloyd: Head and Hands in Harness*. London: Routledge, 2014.

On Woodworking with Kids

Bentinck-Smith, Michael. *It Wood Be Fun: Woodworking with Children*. Groton, MA: Martin and Lawrence Press, 2008.

McKee, Jack. *Woodshop for Kids*. Bellingham, WA: Hands On Books, 2005.

Moorhouse, Pete. *Learning through Woodwork*. New York: Routledge, 2018.

Starr, Richard. *Woodworking with Your Kids*. Newtown, CT: Taunton Press, 1982.

Stowe, Doug. *The Guide to Woodworking with Kids*. Nashville, TN: Blue Hills Press, 2020.

On Wood

Moore, Dwight M. *Trees of Arkansas*. Little Rock: Arkansas Forestry Commission, 1960.

Perlin, John. *A Forest Journey: The Role of Wood in the Development of Civilization*. Cambridge, MA: Harvard University Press, 1989.

Sloane, Eric. *A Reverence for Wood*. New York: Dodd, Mead, 1965.

Supportive Reading

Adamson, Glenn. *Fewer, Better Things: The Hidden Wisdom of Objects*. London: Bloomsbury Publishing, 2019.

Coperthwaite, Bill. *A Handmade Life*. White River Junction, VT: Chelsea Green, 2002.

Crawford, Matthew B. *Shop Class as Soulcraft*. New York: Penguin Books, 2009.

Esterly, David. *The Lost Carving: A Journey to the Heart of Making*. New York: Viking Penguin, 2012.

Korn, Peter. *Why We Make Things and Why It Matters: The Education of a Craftsman*. Boston: David R. Godine, 2013.

Rogowski, Gary. *Handmade: Creative Focus in the Age of Distraction*. Fresno, CA: Linden, 2017.

Rose, Mike. *The Mind at Work: Valuing the Intelligence of the American Worker*. New York: Penguin, 2005.

Sennett, Richard. *The Craftsman*. New Haven, CT: Yale University Press, 2009.

Yanagi, Sōetsu. *The Unknown Craftsman: A Japanese Insight into Beauty*. New York: Kodansha USA, 1990.

INDEX

ABOUT THE AUTHOR

Doug Stowe began his career as a woodworker in 1976, making custom furniture and small boxes. He lives on a wooded hillside at the edge of Eureka Springs, Arkansas, and specializes in the use of Arkansas hardwoods. He is the author of fourteen books and over 100 articles on woodworking. In 2001, Stowe began a woodworking program at the Clear Spring School, designed to integrate woodworking activities to stimulate and reinforce academic curriculum, restoring the rationale for the use of crafts in general education and demonstrating its effectiveness. In 2009 he was named an Arkansas Living Treasure by the Department of Arkansas Heritage and the Arkansas Arts Council for his contributions to traditional crafts and craft education. Stowe also teaches at the Eureka Springs School of the Arts and the Marc Adams School of Woodworking and at woodworking clubs throughout the United States. Stowe's website is **www.dougstowe.com**, and his blog is at **wisdomofhands.blogspot.com**.

CPSIA information can be obtained
at www.ICGtesting.com
Printed in the USA
JSHW031957300422
25411JS00004B/5